Henry Moore

Peter Fuller

Henry Moore

Edited with an introduction by

ANTHONY O'HEAR

Methuen

First published in Great Britain in 1993
by Methuen London
an imprint of Reed Consumer Books Ltd
Michelin House, 81 Fulham Road, London SW3 6RB
and Auckland, Melbourne, Singapore and Toronto

A CIP catalogue record for this book
is available at the British Library
ISBN 0 413 67620 X

Typeset by Wilmaset Ltd
Birkenhead, Wirral
Printed in England by Clays Ltd, St Ives plc

Contents

Acknowledgements

Some of the material used in this book has previously appeared in the following publications:

'Henry Moore: An English Romantic' in *Henry Moore*, Royal Academy of Arts, 1988.
'Modern Sculpture: A Contradiction in Terms', in *Art and Design*, vol. 3, no. 11/12, 1987, pp. 13–21.
'The Visual Arts' in Boris Ford (ed.), *The Cambridge Guide to the Arts in Britain*, vol. 9, Cambridge University Press, pp. 98–145.
'Mother and Child in Henry Moore and Winnicott', in *Winnicott Studies, Journal of the Squiggle Foundation*, no. 2, 1987.
'Henry Moore: Drawings 1979–1983' in *Art Monthly*, Sept/Oct 1983, pp. 9–10.

We are grateful to the Henry Moore Foundation for the photographs included in this book.

List of Illustrations

Introduction

Henry Moore had long been an interest of Peter Fuller's, and Fuller had been working on a monograph on Moore for five or six years before his death in a car crash in 1990. In 1990 this work consisted of a large file of drafts and notes, together with an outline of the whole project. On examining the file in conjunction with the outline, I was able to see that all the material necessary for the project was there in rough at least. Parts of the material had already been published in various places, although some reworking has been necessary in order to integrate them into the text of this book. As editor of the text, I have seen my role as being one of organising Fuller's material according to his outline plan. Apart from a few connecting passages, every word of the text is Fuller's. Naturally the text is not what Fuller would have published himself as a final version, but I hope that readers will agree with me that what we have here is worth having, both as a study of the work of Henry Moore and as an indication of Peter Fuller's concerns and interests as they were shortly before his death.

One of the most striking aspects of Fuller's career was that he never stayed still. His life was, in a true sense, a journey. Peter Fuller's journey had taken him from his Baptist upbringing through Marxism, psychoanalysis and an interest in biology, into the thickets of English romanticism, from which he was beginning to emerge with a new non-dogmatic sense of the sacred. From the perspective of his journey, Fuller's fascination with Moore belongs very much to the penultimate stage, that

in which he hoped to show by reference to Moore that a secular art of high sentiment is still possible in our time. There is no attempt in *Henry Moore* to relate Moore directly to anything transcendent, dogmatic or non-dogmatic. Indeed, the claim made on behalf of Moore is precisely that without religion, without a shared symbolic order, he is able to produce work as charged with meaning and sustenance for us as Lincoln cathedral was for the time in which it was built.

Fuller's strong sense of the material reality which underlies our psyche and our aspirations for something higher never deserted him, even when he was praising artists such as Cecil Collins for witnessing to the divine or angelic. Collins's merit for Fuller, indeed, lay in the way in which he was able to find something of paradise in the here and now, in a beauty stemming from an immaculate inner light within the paintings themselves. What might not entirely misleadingly be called Fuller's materialism was also the basis of his criticism of John Berger's *Ways of Seeing*; in that work, Berger had seemed to imply that a postcard reproduction of a painting was as good as the original, and an Ochtervelt of no less worth than a Vermeer, both being no more than symptoms of bourgeois display. For Fuller, what was crucial in a work of art was not the image or what the work gestured at, but the way in which in a work of art material was imaginatively transformed. We must emphasise here both the need for material work and the need for its transformation. In art, as in life, it is not enough simply to present the given. To reflect our embodied intelligence, the given has to be reworked and refashioned.

It is easy to see how Fuller's artistic explorations led him into biological, anthropological and psychological speculations. He wanted to explore the roots of human

aesthetic creativity in our material and psychic nature as a basis for judging the fruits of creativity in finished works of art. In his thought both about art and about humanity, Henry Moore played a pivotal role, as pivotal for Fuller as Turner had been for Ruskin. For in his work Moore seemed to understand and project both our material roots and our capacity for transforming them, without losing sight of either pole of the creative process. More precisely, in his themes Moore continually returned to the most elementary and elemental aspects of human life and experience, to the psychology of the mother–child relationship, to the mother as landscape, and to our instinctual affinity with natural form.

It was the way in which, in perceiving a Moore sculpture, the perceiver oscillates continually between the materiality of the object and the vision it projects which grounded Fuller's fascination with Moore. This 'double aspect' of a Moore sculpture, held at a mid-point between materiality and ideality, was why, for Fuller, Moore was superior as an artist both to those who fail to transform their material at all (Warhol, Woodrow, Long) and to those for whom image is all ('academic' sculptors of all ages, Warhol again, and to those for whom *Ways of Seeing* suggests an aesthetic agenda). This focus on the double aspect of works of art prevented Fuller from lapsing into pure conservatism in his art criticism. He was not interested in artists who simply reproduced old tricks, as it were, and in so doing failed fully to engage with their material. Indeed, Fuller's criticisms of some of Moore's later public works stem precisely from the way they seem simply to be testifying to the fact that they are Moorean images, without evincing any new imaginative grappling with either material or idea. At the same time, Fuller felt like Moore himself that in some of the early work, Moore had been too influenced by the doctrine of

truth to materials, at the expense of imaginative transformation.

Fuller's stress on the double aspect of the best of Moore's sculpture converges neatly on his interests in both biology and psychology. From biology we see how our higher faculties stem from more primitive dispositions, abilities and conditions without ever entirely escaping from them, and in Moore so much of the sculpture explores analogies between human and animal form, and between life itself and the land and landscape from which it stems and which nurtures it. From psychology and in particular from the work of D. W. Winnicott, Fuller came to focus on the notions of the transitional object and of potential space. For Winnicott the infant (and later the adult) comes to terms with his inevitable separation from the all-providing mother (or nature) and his entry into a world of otherness by putting his own meaning and form on bits of an initially alien world; these bits of that world become transitional objects, thus creating in the world what Winnicott called a potential space for the free play of human meanings. As Fuller points out in his section on Moore and Winnicott, Moore does not simply witness to our potential for creativity; his most important theme is the meaning of the mother and child relationship, felt and executed sculpturally in terms strikingly close to the verbal and psychological accounts of that relationship given by Winnicott.

Talking about art as the imaginative transformation of material, though, says nothing about the upshot of the transformation. Francis Bacon transforms material as much as Moore, and is thus a real artist in a way some of Moore's sculptural successors are not. In the Winnicottian system and in Fullerian terms too, as we learn from the fourth chapter of the book, much recent 'object-

based' sculpture involves no real transformation of material, and so remains at the level of the infantile fetish of a blanket. Bacon, by contrast, does produce fully adult cultural objects in which the world is transformed and given publicly accessible meaning, but a meaning which, in Fuller's words, refuses 'to perceive anything in man except evil and bandaged corruption'. In Chapter Three, Fuller draws an explicit contrast between Bacon's *Three Studies for Figures at the Base of a Crucifixion* and Moore's Northampton *Madonna* – composed, dignified, full of spiritual strength – and insists that we make a choice between the two antithetical visions of man.

Although Fuller was not an aesthetic conservative in a straightforward sense – he did not want artists simply to reproduce old styles and old forms – he was extremely sensitive to the way in which modernism and modernistic rhetoric had attempted to break links with traditions in art. In particular, he deplored the way in which the continuing persistence of English romantic tradition had been occluded in recent decades by a modernism which was aggressively international and aggressively untraditional. One of the themes of *Henry Moore* is the attempt on Fuller's part to paint a portrait of Moore as the last great exponent of the English romantic tradition, unsympathetic to the modern world, as uninterested artistically in technology and as appalled emotionally by the depredations we had wreaked on the environment. Both Moore's early links with Gothic and primitive art, and his late fragmented reclining figures, Fuller sees as profoundly un- or even anti-modern.

Fuller saw Moore's late work as embodying a profound, worrying and ultimately healing account of our troubled relationship with our maternal roots and with nature itself. More precisely, he saw Moore as having,

without access to a living religious tradition, a sculptural language capable of dealing, and dealing positively, with some of the profoundest and most problematic aspects of human life. That Moore created his own sculptural language, and that that language has taken on a quasi-mythical status in our time, there can, I think, be little doubt. On the other hand, there might still be a worry about the extent to which imaginative transformation on its own, even of the power of Moore, can work the sort of human and ecological redemption that Fuller seeks to find in Moore's work. If Fuller had lived to rework *Henry Moore* himself, I am sure that he would have addressed this question directly, as this was the question which was uppermost in his mind at the time of his death. It is, surely, significant that the point at which the Moore manuscript breaks off is one which leads so naturally and inevitably to that question.

In working on Peter Fuller's *Henry Moore*, I have to acknowledge the help given to me by Peter's widow, Stephanie MacDonald. I hope that she feels that the trust she has placed in me has not been misplaced. I must also thank my friend G. A. Philip for his help in transcribing and unscrambling some computer disks which were found among Peter's effects. And I must also thank Jeanette Stevens for typing and retyping the manuscript with such efficiency and good grace.

Anthony O'Hear

Moore's
Problem Reputation

'Complete sculptural expression,' Henry Moore once wrote, 'is form in its full spatial reality.' No sculptor this century has had a greater grasp of such 'spatial reality'.

But Moore also said that no 'deep or really moving art can be purely for art's sake'. He always insisted on 'a spiritual vitality' which 'goes deeper than the senses'. A good work of art, according to Moore, is 'an expression of the significance of life', 'a stimulation to greater effort in living'.[1]

The originality of Moore's contribution within the sculptural tradition cannot be doubted; but the significance of his work extends beyond the history of art. Although resolutely secular, Moore's sculpture constitutes one of the most commanding spiritual affirmations of our time. Indeed, as we move into the ethical and aesthetic chaos of the *fin de siècle*, the robust grandeur of his vision rises like a rock. We can feel confident that whatever judgement the future may pass on the art of our century, and however Moore's reputation now stands with the artistic establishment of our country, Moore's sculpture will endure.

I can well remember the first time I heard about Henry Moore's sculpture: it was in, I think, 1952, and I was five years old. A friend of the family had come to lunch. I had

a serviette ring, which consisted of a circular hole in a piece of plastic to which the simplified head of a dog had been attached on one side, and paws and tail on the other. I stood this ring on its head by my plate, and the family guest commented, 'It looks like a Henry Moore.' My father turned to me and said, 'Do you know who Henry Moore is?' I said, 'Yes, he had his head cut off.' I had confused him in my mind with Sir Thomas More. Everyone laughed, and it was explained to me that Moore was a sculptor who made holes through his figures.

The incident perhaps stuck in my mind because I was embarrassed by my own ignorance: and yet it shows how well known Moore was at that time. For I doubt whether my family could have named any other living British artist; and they certainly would not have expected their son to have known what his work looked like. This was a period when Moore was as much a part of English life as rationed orange juice, the Festival of Britain, and the Coronation, and the subterranean influence of John Bowlby's *Child Care and the Growth of Love*.

Of all artists, Moore's reputation is perhaps the hardest to assess. Moore's early exhibitions were treated with ridicule – though not with as great ridicule as Jacob Epstein's, to whom Moore was always grateful, because he took the 'brick-bats' for modern sculpture. It is true that some of Moore's critics said that he had 'out-Epsteined Epstein'; but, in the early days, there were many discriminating supporters in the quality press. Moore's opponents were, on the one hand, academics who felt their aesthetic was threatened, and on the other the gutter press.

In the 1920s and 1930s, Moore's reputation grew: he gained the support of such apostles of the Modern

Movement as Herbert Read, R. H. Wilenski, and J. M. Richards. But his work was also greatly admired by Kenneth Clark, the youthful Director of the National Gallery, and opponent of the Modern Movement in art. For Read, Moore was a pioneer of modern sculpture; for Clark an upholder of classical civilised values in a world which was generally defying and endangering them.

The dilemma presented by these laudatory, but nonetheless conflicting views of Moore remains unresolved to this day. In recent years, it has been fashionable (especially among artists and critics) to praise the first two phases of Henry Moore's development – the 'direct carving' of the 1920s, and the experiments of the 1930s – at the expense of the public sculpture of the 1940s, and the 'late phase' which began in 1958. But I believe this to be a shortsighted view. The strength and freshness of the sculptures of the 1920s is not to be denied, any more than the novelty and ingenuity of much of his work in the 1930s. But Moore achieved his full greatness as a sculptor only in 1944. By then the reevaluations and innovations had been made; Moore was ready to elaborate all he had learned and discovered in a sculptural vision which was his own. The great pieces of his third and fourth stages are spiritual statements of a profundity, complexity and originality which no other sculptor in the post-war era has begun to approach.

The roots of Moore's popularity were established in wartime when his war-drawings, and studies like Geoffrey Grigson's Penguin *Modern Painters*, began to turn him into a household name. This was accompanied by an increasing critical involvement in his work by the British Council, which led to Moore becoming one of the best-known names of post-war art, anywhere in the world. Moore's work was subject to brilliant

3

reinterpretation by a new breed of critics like Alan Bowness, David Sylvester, John Russell and Robert Melville. He was created a Companion of Honour in 1955, and throughout the last thirty years of his life he was invested with honours and given retrospective exhibitions throughout the world. His work has been more widely distributed throughout the Western world than that of any other sculptor, living or dead. There are Henry Moores in Parliament Square in London, and at the Lincoln Center, New York. No city in the West seems complete without at least one gargantuan cast of a Moore dominating one of its choice positions: in a park, on a plaza, or outside a modern building. In 1977 a Henry Moore Foundation was opened in Much Hadham. By the time Moore died in 1986 he had achieved unprecedented recognition for a sculptor. But, equally in 1986, many younger sculptors, and much 'informed' critical opinion, were looking to other things, and were arguing that Moore's work had become remote from the concerns of a contemporary artistic culture. To many, even in the 1960s, he seemed to have become almost a dinosaur, out of touch with the new and modern world. Just as Moore had once been acclaimed by the spectrum of critics – now it seemed that formalists, like the American Clement Greenberg, and social realists, like John Berger, could agree only in their low estimate of Moore.

In recent years, however, the story has twisted yet again: for there is now growing recognition that much of the art of the last twenty-five years is of no very great consequence, and Moore's refusal of certain aspects of it is seen as a strength. The old and patronising assessment that he had made vigorous things only in the 1920s and 1930s also seems quite inadequate. The outlines of a new way of understanding Moore are beginning to

emerge. His greatness can be seen to have resided in his sense of continuity with the past at a time when such things were not highly regarded; in his sense of union with nature; in his replenishment of national tradition; and, perhaps above all, in his standing for a grand and central tradition of sculpture when that was threatened. Moore appeals to a world which is tired of the triumphalist claims of modernity, which looks back again to the infant–mother relationship, and to the sense of oneness with nature that flows out from and extends to that.

Moore's work itself was subject to change – to great changes which we will refer to again and again. He begins with a certain primitiveness in the early pieces. In the 1930s, he engages in formal invention. The union of these two comes with the contribution to Moore's work of a certain romanticism, at a time when his reputation was growing both nationally and internationally. There follows a more intimate and formal phase. And yet we can see that at every point Moore's work seems to offer a challenge: at its heart, and at its core, is a view of what sculpture is – that sculpture, traditionally conceived, can speak eloquently to the contemporary world; but there is a rejection of that world – of its flatness, superficiality, and sense of disunity of form. There is an ambition to speak of the great themes of human life, at a time when sculpture is a bag of tricks and gimmicks.

Moore sometimes, no doubt, over-reached himself. Much has been made of his 'inflation of scale' and his 'monumental' ambition. Not all such criticisms are without foundation: those aware of Henry Moore's failing physical powers in his last years could only regard with a certain cynicism the continuous pro-duction of 'original' full-scale casts and carvings issuing from his studio. Practices for which Moore condemned

5

the Victorians were, apparently, legitimised by his own advancing years.

Despite such criticism and despite weaknesses in Moore's work (later and earlier, I shall argue), we will see how, for all its variety, changes of emphasis and imagery, Moore's mature work has shown a remarkable unity of vision and purpose, moving freely between opposites. But it is also part of my thesis that Moore is a representative of a continuing and anti-modern tradition in English art and English sculpture, perhaps more so than he himself was always ready to admit. We are, today, in a position to value Moore for what he conserved, for his sense of continuity with a threatened civilised past, not only for his originality, but for his grasp of tradition upon which such originality is based. We are beginning, perhaps, to see him as the last great master of the English Romantic tradition. In order to make out this claim, before looking in some detail at the various phases of Moore's career, we will now consider Moore's relation to his sculptural antecedents.

Moore's
Sculptural Antecedents

Sculpture is probably the oldest and certainly the most deeply and inherently conservative of all the arts. Indeed, in myth and religion, the primal acts of creation resemble sculpture: 'And the Lord God formed man of the dust of the ground, and breathed into his nostrils the breath of life; and man became a living soul.' As late as the mid-nineteenth century, when Ruskin surveyed the Alps, he saw them as God's sculptures, a 'great plain, with its infinite treasures of natural beauty, and happy human life, gathered up in God's hands from one edge of the horizon to the other, like a woven garment, and shaken into the deep falling folds, as the robes droop from a king's shoulders'. Even for those of us who do not believe, sculpture has not necessarily lost these elemental associations. Sculpture is an art form which involves the imaginative transformation of inert matter, the working (if not the breathing) of signs and semblances of life into clay, wood, stone, and metal.

As an art form sculpture expresses more immediately than most what the psychologist D. W. Winnicott called the 'transitional' nature of creative experience. The pleasure we derive from it is derived from the fact that this block of stone before our eyes is, at one and the same time, a block of stone and a representation of a

couple locked in a kiss. Good sculpture depends upon the maintenance of this paradox; its power is immediately diminished if either the material is presented as something intractable, matter which over-burdens the image, or if the image is allowed to subsume the material, smothering it in conceits, virtuosity, and extravagant illusions.

By its very nature, sculpture has always been among the most limited and restricted of the plastic arts: the aesthetic possibilities peculiar to sculpture, as opposed to other human arts and activities, have to do with this imaginative encounter between the human subject and his materials – materials which are, of course, not only physical, but also include the conventions and devices which are the inheritance of a living sculptural tradition. Today, even traditionalists would acknowledge that there are two modes proper to the pursuit and practice of sculpture: the carving and the modelling mode. (The varieties of assemblage, collage, and construction are derivatives of the latter.) But it was not always so. 'By sculpture,' wrote Michelangelo, 'I mean that which is done by subtracting [*per forza di levare*]: that which is done by adding [*per via di porre*, i.e. modelling] resembles painting.'

For Michelangelo, the issue was much more than a nice theoretical distinction: for, at the time of the Renaissance, 'modelling' was assuming an ever greater importance within the sculptural tradition. As the name of the practice implies, it was associated with the growing use of 'models', or small, preliminary studies made in clay or wax; and with a new technology – that of the 'pointing-up' machine. With these devices, and a drill, the sculptor could mechanically reproduce a large version of a small maquette; or he could even employ others to do so on his behalf.

Michelangelo certainly knew about the new techniques. As a young man in Florence, he made extensive use of the drill, up until the completion of his *David*; but thereafter he deliberately reverted to chiselling. He seemed uninterested in working in bronze, and remained faithful to direct carving, in stone. As Rudolf Wittkower has shown us, 'Michelangelo was the artist who made more elaborate use of the claw chisel than any artist before or after him.' This tool 'allowed him to define and redefine natural form, to bring the subtlest modulations of bodies, muscles, skin and feature'. The power of Michelangelo's later works depended, in part, on this inextricable fusion of imagination, execution, and materials. Of course, there have been droves of sculptors who have used the claw chisel without possessing Michelangelo's genius; nonetheless, it remains the case that he could not have expressed his genius as he did if he had relied so extensively on any other tool.

There were aspects of Michelangelo's vision that were 'Modern', in that he depicted man as a living, corporeal being. If the word 'humanist' means anything, it can help us to distinguish between the art of Michelangelo and that of the medieval world. And yet it seems important to emphasise that this 'new' vision was only realised through the exercise of the most stubborn restraint in matters of technique and materials. Michelangelo, at least, insisted on the essentially conservative character of that art over whose subsequent history he was to cast such a long and daunting shadow.

After Michelangelo's death, Western sculpture was subject to the opening of an ever wider gap between imagination and the working of materials – which was sustained by the use of increasingly sophisticated mechanical techniques. The sculptor liked to think of himself more and more as a man of mind, not as a

lowly manual labourer. The sculptor conceived of ideas, images and ideals, and often employed craftsmen to realise the finished works in stone, or, increasingly commonly, bronze.

Of course, this sort of generalisation requires a good deal of qualification. Nonetheless, there would, I think, be few dissenters from the view that with the death of Michelangelo, Western sculpture began to undergo a decline; or that this decline was associated with (though not necessarily caused by) an over-emphasis on the idea, or ideal, and a diminution of the importance given to the physical transformation of materials. This enfeeblement of the art went with an ever more narrow preoccupation with advancing upon the perfection of the Greek ideal (which could find expression in abstract or at least mathematical concepts); with a decline in the use of such primitive instruments as the claw chisel, and the rise of machinery and modern productive techniques: i.e. an ever more extensive use of drills, pointing-up machines, 'editions' of bronzes, and of craftsmen and foundries. The sculptor had elevated himself from the role of a humble mason to that of a man of ideas and of enterprise. Indeed, a nineteenth-century sculptor's studio became increasingly like the office of a small manufacturer – and, in many instances, he was no closer to his finished products.

'Sculpture', in the sense that Michelangelo had conceived of it, did not die out. Indeed, much more carving took place in Britain in the nineteenth century than art historians once realised; for example, John Gibson, who was the most prominent of the neo-Classicists, was, in fact, an exquisite, if virtuoso, carver. But, by and large, the cutting of stones reverted to being a lowly occupation, pursued by decorators of architectural façades, ecclesiastical craftsmen, and makers of funeral monu-

ments – *not* by Fine Art sculptors. It is perfectly possible to exaggerate the debilitating effect which this division had upon the life of sculpture; and there have been many in the twentieth century who have so exaggerated it. Later nineteenth-century England, after all, produced Thomas Woolner, Alfred Stevens, George Frederick Watts, Alfred Gilbert, and a whole host of talented 'New Sculptors' in the 1880s; the sculptural tradition in this country, in the last fifty years of the nineteenth century, was more vigorous than it has so far shown itself to be in the last fifty years of the twentieth century. Even so, it would be a foolish man who endeavoured to argue that for all their innovations in status and technique, the late Victorians had actually improved upon sculptural practice since Michelangelo's day. The sculptor may have removed himself from messy and tiresome tasks; but his art, as sculpture, often seemed diminished and impoverished.

Indeed, as I understand it, the 'New Sculpture' movement of the 1880s was an impassioned attempt to reverse this process, to forge an aesthetic which breathed new life into the idea of sculptural imagination, and which nonetheless was fully compatible with contemporary means of production. The movement has been well described by Susan Beattie, in her book, *The New Sculpture*. 'Behind every aspect of the New Sculpture,' Beattie writes, 'from its profound *esprit-de-corps* to the individual achievements of its leading figures, lies the shared objective that was its true controlling force; no obedient following of nature but the most turbulent redefinition of sculpture's role ever to take place in Britain.' She goes on to say that whether reaching out into the community as decorators in the service of architecture and industry, or challenging the old, elitist concept of high art in their enthusiasm for the mass-

produced, marketable art-object, or investigating, in low-relief carving and modelling and the use of colour, sculpture's affinity with painting, 'the New Sculptors advanced together upon ground prepared for them by Alfred Stevens'. She adds, 'In their passion to express, through the solid, material medium of stone or clay, the intangible, secret forces of human imagination, they justified his agonised struggle for self-determination and the cause of art without boundaries.'

In other words – and the point needs to be made with some force – the New Sculptors were attempting to fuse together a traditional conception of the sculptor as an imaginative artist with modern productive processes; they were endeavouring to become *modern sculptors*. The claims Susan Beattie makes on their behalf are not only sympathetic, but convincing. And yet . . . Here we must pause. Because if the twentieth century has hitherto been blind to the achievements of the New Sculpture movement of the 1880s, it is because it has recognised that it was attempting an impossible marriage: 'What chance has Vulcan against Roberts & Co., Jupiter against the lightning-rod and Hermes against Credit Mobilier?' (Karl Marx). Would it not be better simply to forget about Vulcan and Hermes, and to give the lightning-rod and the Credit Mobilier their head?

That, of course, is what the true 'Pevsnerian' modernists sought to do. Pevsner, it will be remembered, saw the duty of the Modern Movement as being to express fully the twentieth century. In so doing it had to possess 'faith in science and technology, in social science and rational planning and the romantic faith in speed and the roar of machines'.[1] But the pioneers of Modern sculpture such as Jocob Epstein, Eric Gill, Gaudier-Brzeska, Barbara Hepworth and Moore himself, were not inspired by anything like faith in science and

12

technology when they built on, and reacted against, what the Victorian 'New Sculptors' had achieved.

There was, of course, a difference between rhetoric and practice. For the great sculptural movement that arose in Britain in the early twentieth century has again and again been associated with the Modern Movement; i.e. with that movement which, as we have seen, Pevsner and others associated with faith in technology, rational planning, democratisation, the triumph over nature, and the machine aesthetic. And yet if anything bound these sculptors together, if anything differentiated them sharply from the generation which had preceded theirs, and those which were to follow, it was the refusal of modernity. Certainly, like Moore, they wanted to dispose of the residues of Greek mythology, and Greek canons of beauty, but they most certainly did *not* want to replace them with the lightning-rod, or, least of all, Credit Mobilier. Rather they wanted to revitalise sculpture by bringing back that which the advance of the modern world had come close to excluding.

Needless to say, there was nothing *new* about such an enterprise. At the beginning of his little book, *A Concise History of Modern Sculpture*, Herbert Read remarks – quite rightly – that Rodin himself had a recuperative, rather than an avant-garde, conception of sculpture. 'Rodin,' writes Read, 'began with the ambition to restore the art of the medieval cathedrals.'[2] Rodin was a sculptor whose 'whole purpose . . . had been to restore to the art of sculpture the stylistic integrity that it had lost since the death of Michelangelo'.[3] But if the British differed from Rodin, they did so because they looked backwards even harder than he had done: Rodin, after all, was not only a quintessential modeller; he also employed the pointing-up machine as diligently and as persistently as any Victorian salon sculptor.

But, with the British, matters were different. Take the case of Eric Gill, whose contribution to modern sculpture is supposed to have been his rehabilitation of stone-cutting, or direct carving. Eric Gill shared with Rodin an enthusiasm for the medieval world. But he differed from Rodin in the relentlessness with which he refused modernity. Gill was a convert to Roman Catholicism, who wore medieval dress and who believed in communal, quasi-monastic life, even though, notoriously, he was not an enthusiast for celibacy. Gill's espousal of direct carving was part and parcel of his wholesale and uncompromising *refusal* of the modern world; it was inseparable from his view that art could be made with tools, but not through association with machines. 'Machinery . . . was not invented to make things better or even to help the workman. It was not introduced either by the workman or the designer of things to be made. Its origin were neither humanitarian nor artistic, but purely commercial.' The sculptor, Gill believed, should turn his back on modern machinery and take up his tools once again. Stone-cutting, for him, was the affirmation of a form of labour, at once physical and sacramental, which modern industrial capitalism excluded.

Or take the case of Gaudier-Brzeska, who died in the trenches in 1915. According to the historians of modern art, Brzeska's importance resides in his 'discovery' of the doctrine of truth to materials. As a result of Brzeska's brief period of posturing with the Vorticists, this is given the glow of radical innovation. It isn't just that 'truth to materials' was also central to Michelangelo's profoundly conservative view of sculpture: 'The best of artists have no thought to show/What the rough stone in its superfluous shell/Doth not include; to break the marble shell/Is all the hand that serves the brain can do.'

The concept permeated the subterranean and aesthetically conservative anti-academic currents of the nineteenth century. Gaudier-Brzeska had certainly studied Ruskin closely. (We need not doubt that when Brzeska declared, 'Sculpture is the mountain', he was echoing Ruskin's vision of the natural ranges as the sculptures of god.[4]) 'Truth to materials' was one of the core doctrines of Ruskin's aesthetic teachings, and, beyond that, of many other nineteenth-century Gothic Revivalists; 'truth to materials' was their rallying cry against the trickery, chicanery, and deceptiveness of modern industrial processes, a rallying cry which, when linked with a concept of the imaginative, and the spiritual, echoes back to the whole lost world of Gothic art and Gothic work.

Or take the case of Epstein. Like Brzeska, Epstein flirted with modernity, in the form of the Vorticist movement. But his entire life's work, after the creation of the *Rock-Drill*, can be seen as a repudiation of that which is modern. It was not just, as he himself repeatedly insisted, that he endeavoured to give expression to a human and spiritual dimension, which emphasised those aspects of life which are common from one moment of civilisation to another. As Evelyn Silber has argued, he deliberately chose as exemplars for his architectural sculpture, 'the cathedrals and churches of medieval France and fifteenth century Florence'.[5]

The early twentieth-century 'pioneers' of modern sculpture were 'radicals' in a similar sense to the Pre-Raphaelites; they endeavoured to recuperate something which had been lost, not to create something entirely new. The early Victorians believed that their culture was better than any that had previously existed. William Frith was not alone in his conviction that the history painter, Daniel Maclise, was the greatest artist who had

ever lived. Holman Hunt and Dante Gabriel Rossetti appeared shocking in the mid-nineteenth century because they dared to suggest that there might have been something in a 'primitive' like Benozzo Gozzoli which was absent from Maclise. They thus affronted the Victorians' belief in progress: they showed that the 'advances' of civilisation had also involved men and women in spiritual and aesthetic *loss*, and that the dominant art of their day reflected, or was infected by, that loss. The greatness of the early twentieth-century sculptors depended on something similar; the power of their best work derives from its *otherness* from the modern world, its affirmation of a form of imaginative life, and of a tradition of technical and creative practices, which that world seemed determined to exclude.

No one exemplifies this more than Henry Moore himself; the much-repeated judgement that Moore was the greatest British artist of the twentieth century is, I believe, unassailable. But its articulation often evades the fact that Moore's works were an uncompromising indictment of the concerns of our century, and an affirmation, in a peculiarly sculptural way, of other and more enduring human values.

Those recent critics of Moore who claim that his work was remote from the concerns of a contemporary artistic culture are in one sense right. Though Moore was a highly original artist, he was not, as has sometimes been suggested, a pioneer of modern sculpture; on the contrary, despite his rhetoric and that of some of his advocates, his achievement right from the very start was realised largely against the grain of modernity. But if Moore's reluctance to espouse the modern world in all its aspects – the very 'avuncularity of his modernism' as Charles Harrison described it[6] – was once construed as a weakness, a failure of nerve, today it is beginning to

appear as among Moore's greatest strengths; for, these days, modernism itself has begun to look, as current jargon has it, 'problematic'. Moore is beginning to be seen in his true colours as the greatest twentieth-century exponent of a continuing, British, romantic tradition, a tradition which, with the choking of the motor of modernism, may be undergoing something of a renaissance. How Moore came to represent and develop that tradition, and to affirm its artistic and human values, is what will concern us in the next chapter.

Moore's
Life and Art

i *Early Years*

Henry Moore was born on 30 July 1898, in the Yorkshire town of Castleford, the seventh of eight children born to Raymond and Mary Moore. Much, too much Moore believed, has been made of the fact that his father was a mineworker: be that as it may, Raymond Moore had been a miner, although he had retired by the time of Henry's birth, owing to injuries sustained in a pit accident.

Moore's biography then begins in Yorkshire, in a majestic landscape whose beauty could not have failed to impress him, but it was a beauty somehow violated by industry. We may see in this landscape the source of themes which run through his work: nature as the extension of the mother, the earth mother violated by miners and warriors, full of tunnelling and cutting. In his work a strong, powerful and instinctive response to the Pennine rocks fuses with an equally strong and instinctive response to the female body. The female body is seen as a child views the mother's body, as a source of sustenance, nurture and aggression, as an environment, rather than as an object of sexual desire.

In later life Moore often told the story of how his

mother suffered from bad rheumatism in the back. 'She would often say to me in winter when I came back from school, "Henry, boy, come and rub my back." Then I would massage her back with liniment.' He related this experience to a particular seated figure of a mature woman he made in 1957. 'I found that I was unconsciously giving to its back the long-forgotten shape of the one that I had so often rubbed as a boy.'[1] One feels that such early experiences somehow inform the vision he wished to convey through all his later sophisticated sculptural skills.

But these feelings and visions would have remained at the level of psychology, had Moore not found a tradition within which to make them real. In Castleford, the world of culture was confined, apart from visits to Methley Church, where Moore saw his first carvings. His study of the Gothic carvings there seems later to have merged with his sense of Englishness. We know that when he visited Europe for the first time after the war, he was to pine for the sense of a tree that can be called a tree, for a tree with a trunk, and for the feel of the English Gothic. He told William Rothenstein that he believed that he would return a violent patriot and commented on the inspiration he found in 'our English landscape'.

As a child and a young man, Moore's talents did not go unrecognised. His father, though patriarchal, was a nonconformist autodidact, who was ambitious for his children, and did nothing to discourage Henry's improbable ambition to be a sculptor. Indeed, as Moore himself recounted, Raymond Moore owned a drawing by Ruskin, and introduced the young Henry to Ruskin's thought, a fact of some significance for Moore's future work. Moore was also encouraged at his secondary school by an exceptionally enlightened art teacher, Alice

Gostick, who forms the shadowy link between him and the sense of tradition, the wider culture in which his dreams began to develop into a reality.

Moore's development as an artist was interrupted by active military service in 1917. After training as a Lewis gunner he was sent to France and gassed at the battle of Cambrai in December 1917. After convalescence, he volunteered once more for active service, reaching France again just before Armistice Day in 1918. Moore's military service was undoubtedly of relevance to his sculptural vision, and to its sub-themes of an injured and godless landscape, of man's inhumanity and of the redemptive power of artistic form.

ii *First Sculptural Phase* (1919–32):
Looking Further Back

After the war, Moore went on to study at Leeds College of Art in 1919. In 1921, he went to the Royal College of Art, first as a student, and then as a teacher, where he stayed until 1931. In 1929, he married a student of painting from the Royal College, Irina Radetsky. (The Moores' only child, Mary, was born in 1946.) While at Leeds, Moore discovered Roger Fry's *Vision and Design*, with its illustrations of Negro sculpture, which affected him greatly. In his early years in London, he spent much of his spare time in the great museums at South Kensington, and in the British Museum. He soon began to question what he had been taught; and, encouraged by Jacob Epstein, he started to make a close study of African and ancient Mexican sculpture. In 'primitive' art, Moore found an 'intense vitality' and a 'virility and power'; he felt this was because such sculpture was

'made by people with a direct and immediate response to life', and was not just an activity 'of calculation or academicism'. At this time, he developed the view (which he was later to revise) that Greek sculpture, and the Western tradition which had sprung from it, 'was only a digression from the main world tradition of sculpture'. He insisted that a century or so of Greek art need no longer 'blot our eyes to the sculptural achievements of the rest of mankind', and in an article he wrote enthusiastically of the achievements of 'Paleolithic and Neolithic sculpture, Sumerian, Babylonian and Egyptian, Early Greek, Chinese, Etruscan, Indian, Mayan, Mexican and Peruvian, Romanesque, Byzantine and Gothic, Negro, South Sea Island and North American Indian'. And in a letter of 1924, he spoke of the 'wilful throwing away of the Gothic tradition'² in the West.

Moore's own early work reflects all these influences. He did not achieve his mature vision easily, but from the start we find in him a rediscovery of the vitality of direct carving and of the 'transitional' qualities of sculpture. He reacted strongly against the vapid classicism, and the 'pointing-up' techniques favoured by some of his teachers, and became an advocate of the doctrine of 'truth to materials'. He was also affected by what Eric Gill had to say about the importance of direct carving in stone, through which he hoped to 're-sacralise' human labour and to restore it to its medieval condition.

Moore's sculpture of the 1920s shows the strongest and most direct influence of 'primitive' art, and the most unswerving commitment to the principles of direct carving and 'truth to materials'. Some of his early pieces reveal immediately how they were clawed from the stone, as Michelangelo also clawed, displaying everywhere the signs, tracks and traces of the chisel, and the labour, through which they were wrought. Moore redis-

covered the value of declining to impinge upon mater-
ials; but these works have not yet found their forms;
they are often little more than replications of what, say,
the ancient Mexican artists had already attempted. They
appear to be overwhelmed by the strangely remote, and
unsatisfying, inertia, if not of Vulcan or Hermes, then of
Chacmool, the rain-spirit, and the ancient gods of
Mexico and of Egypt: as Epstein was to say of them, it is
as if, before them, we can do no more than ponder in
silence.

One of Moore's earliest sculptures is *Mother and Child*
of 1922; an appeal was recently made for information
concerning the whereabouts of this work, but, at the
time of writing, that remains unknown. Even from a
photograph, however, it is easy enough to see how both
the imagery of the piece, and the way in which it was cut
from the stone, were of a kind which was to dominate
Moore's imagination and his working practices,
throughout the 1920s.

The work shows a woman seated on the ground with
her arms around her knees; a baby's head and hands
protrude incongruously from the side of the mass of
stone which represents her body. The shape of the
sculpture follows closely that of the block of stone from
which it has been coarsely, if vigorously, hewn. There is
no sense of finish to the forms or the surfaces and the
tracks of the claw chisel are visible everywhere,
although they are especially clear at the base of the
woman's stumpy legs. The work is closely related to a
fifteenth-century Aztec sculpture of a seated man,
believed to be the god Xochipilli, from the Bullock
Collection in the British Museum and reveals how
intently Moore had been looking at 'primitive' sculpture
in the visits he made there at this time.

In one sense, this *Mother and Child* set the agenda for

Moore's *oeuvre* in the 1920s. He carved masks, stone heads, and animals; but his favoured themes were pursued within a surprisingly narrow range. 'There are three recurring themes in my work', Moore himself once said, 'the "Mother and Child" idea, the "Reclining Figure" and the "Interior/Exterior" forms.'[3] At least two of these were markedly present in this 1922 *Mother and Child*; all were to emerge strongly during Moore's first decade as a practising sculptor.

Despite being heralded as the foundation of the Modern Movement in sculpture in this country, Moore's early sculptures were almost the antithesis of modernist ideals. Far from seeking to be 'fully expressive of the twentieth century' Moore seemed to want to turn his back on the modern world and all its works. As John Rothenstein once pointed out, were, say, *Mask* of 1924 'placed with others in a collection of ancient Mexican sculpture, it would take an experienced scholar to pick it out as a modern derivation.'[4] Moore's imagination shows no concern with, let alone faith in, science, technology, social science, or rational planning, and is devoid of any suggestion of 'romantic faith in speed and the roar of machines', which, as far as Moore's sculptures were concerned, might never have existed. Nothing about his sculpture suggested a desire to triumph over the world of nature, or to dispense with a sense of personal security: rather, from the beginning, Moore's work seemed inspired, at least in part, by a yearning for harmonious fusion between image and matter, infant and mother, figure and ground, subject and object. His sensibility was not only un-modern; it was, in many ways, profoundly anti-modern – and this, perhaps, was one reason why at first it seemed to many so scandalous, indeed so 'primitive'.

Nevertheless, this is not to say that when Moore's

work began to appear in the London galleries it was unprecedented. Both Gaudier-Brzeska and Eric Gill had already made their mark, and Jacob Epstein had placed their archaising sculptural practices on a wider and more public stage. The twentieth-century British sculptural 'pioneers', including Moore, were, in aesthetic terms at least, reactionary. They took their standards from the past; their strengths were rooted in their unswerving desire to restore lost sculptural values, to reaffirm the vitality and spirituality of pre-Renaissance art. As suggested in the last chapter, the best British sculpture in the early decades of this century was, in terms of its cultural stance, rather more like Pre-Raphaelitism, or at least the Gothic Revival, than it was like an avant-garde movement. The comparison with Pre-Raphaelitism is, I think, peculiarly appropriate in the case of Moore as what was new, original and fresh about his work was that imaginative and spiritual vision of nature which it embodied. But, at first, this was by no means evident; as John Rothenstein has written:

> If those . . . who had the perception and the
> foresight to acquire Moore's work in the
> 1920s were to compare examples of it with
> examples of the Mexican and other ancient
> sculpture which he assiduously studied and
> which he has always been ready to admit to
> be the very foundation of his art, it would be
> plain that many of them were little more than
> exercises – powerful and perceptive, but
> exercises none the less – in various early
> styles.[5]

They are exercises because neither the imagery, nor the forms, are yet Moore's own.

But as the 1920s became the 1930s Moore's work turned. Look, for example, at the marvellous little alabaster of a *Suckling Child* which once belonged to Canon Walter Hussey: there is no precedent, or prototype, for this moving piece in the art of the ancients; or compare the well-known *Reclining Figure* of 1929 from Leeds, with the *Reclining Figure* in green Hornton stone, from the National Gallery of Canada, which Moore made the following year. The Leeds figure is much better known, perhaps because it is easily and immediately related to a Mexican Chacmool carving, certainly know to Moore in a photograph, and a cast of which he may have seen in Paris; but the Ottawa *Reclining Woman* is, I believe, a greater sculpture: there was no precedent from the past for this audacious bunching up, and peaking of breasts and knees of a sculpted reclining figure into a mountain range.

How, therefore, did Moore arrive at these compelling sculptural images and forms? He himself always placed great emphasis on his first reading in 1921 of Fry's essay on 'Negro Sculpture', in *Vision and Design*. 'Once you'd read Fry,' Moore commented, 'the whole thing was there.'[6] (Fry had stressed the 'complete plastic freedom' of African art, and the way in which the African artists 'really conceive form in three dimensions'.[7]) Everything else, Moore liked to imply, came from his visits to the British Museum while he was a student at the Royal College in the early 1920s.

Moore's comments on Fry have always been taken at face value, yet Moore's understanding of art was radically unlike Fry's; for Fry's doctrine of 'significant form' propelled him towards a position from which he defended the autonomy of art, and its separation from other levels of life and experience. Moore, on the other hand, always retained a more ethical conception of high

25

aesthetic experience; indeed, in 1951, an exhibition of African tribal art led Moore to conclusions almost exactly the opposite of those of Fry: 'I do not think . . . ,' Moore said, 'any real or deeply moving art can be purely for art's sake.'[8] Again and again Moore distinguished between 'the provision of pleasant shapes and colours in a pleasing combination' and art which was 'an expression of the significance of life, a stimulation to greater effort in living'.[9]

There were, needless to say, influences other than those of Fry which Moore rarely acknowledged; we have mentioned the depth of his debt to Epstein, which Moore himself consistently underplayed.[10] Moore was, in most respects, a generous man; but he manifested an almost compulsive need to ablate the memory of those artists who had significant short-range influence upon him, preferring to admit to having learned only from the likes of Michelangelo and Masaccio. Moore's few comments on British Victorian sculpture suggest that he agreed with the judgement of his friend, Herbert Read, that 'The practice and appreciation of sculpture in England has been virtually dormant, if not dead, since the Middle Ages.'[11] There are, however, indications that Moore was in fact more deeply influenced by, say, G. F. Watts, and even by Frederick Leighton, than he acknowledged. Compare, for example, the Titans in Watts's 'House of Life' designs with Moore's handling of the reclining figure; or Watts's *Mother and Child* of 1903–4 with a drawing like Moore's *Mother with Child holding Apple II* of 1981. But whether or not there was any direct influence, both these artists shared similar aesthetic ambitions: Moore, we might say, was closer to Watts than he ever was to Fry. Moore longed to create a spiritual and yet humanist art which touched upon the universal truths which lay behind the trapping of myth;

for Moore, as for Watts, abstraction was a means to this end, rather than an end in itself.

Moore liked to give the impression that he followed a lonely path while he was at the Royal College between 1921 and 1931, inspired only by remote prototypes in the British Museum, but I am convinced that insufficient emphasis has been placed on the influence of his teachers and colleagues at the Royal College of Art, who were not all, as they are sometimes represented, ossified academics. Leon Underwood, for example, had a spiritual and imaginative view of art, not significantly different from Moore's own. In 1928 Underwood went to Mexico, and in 1929 he painted an oil, *Chacmool Destiny*, which immediately preceded Moore's sculpted version of this subject.[12] Gilbert Ledward, professor of sculpture at the College from 1926 until 1930, is often said to have been antagonistic to Moore; and yet the similarities between Ledward's private (rather than his commissioned) work and Moore's at this time are striking. For example, in 1930 Ledward completed a Roman stone sculpture, *Earth Rests*. 'The subject of this piece,' Ledward explained, 'is "Earth rests, the ancient fires are still; her jewels are set, her knees drawn up like hills." ' He added that the 'solidity of the figure' was 'definitely established by the original block of stone' and that this shape had been deliberately retained to the end, so that 'the prominent parts of the figure combine to form outer planes which still represent the original surfaces of the stone'.[13] That is, he recognised the appropriateness of 'truth to materials', rather than classical canons of beauty, in depictions of the Earth Mother as a reclining figure.

Equally, however, the influence of Underwood and Ledward – who were neither academics, nor modernists – on Moore should not be exaggerated. For, as

27

Underwood himself well recognised, the ideas, and indeed the imagery, with which they were preoccupied in the late 1920s had a long history within the English romantic tradition; Ruskin had always seen in the mountain ranges the quivering presences of the women he never knew. He had found in the lowlands 'a spirit of repose', but saw 'the fiery peaks' as 'having bosoms and exulting limbs, with the clouds drifting like hair from their bright foreheads'.[14] 'Living art,' Underwood once wrote, 'feeds upon life and imagination. Past styles can be but mere spices in its frugal diet.'[15] Moore's work was coming to resemble Ruskin's words in another way too: 'Moore,' Herbert Read wrote, '. . . believes that behind the appearance of things there is some kind of spiritual essence, a force of immanent being which is only partially revealed in actual living forms.'[16] It was as if Moore was, albeit unwittingly, beginning to realise his own version of Ruskin's imaginings in stone.

Of many of Moore's early works, I must admit that I have come to share John Rothenstein's harsh judgement that they are little more than exercises in various styles. But by the end of the 1920s, the stuffy aroma of the museum, and the ghosts of studied prototypes, despite the boldness of their handling, begin to evaporate. Nevertheless, both Moore's early carvings and his influence as a teacher were severely criticised. He had been encouraged by Epstein, who bought an early study of a baby suckling at the breast and who introduced the exhibition Moore held at the Leicester Galleries in 1931. Partly as a result, Moore had to endure some of the outrage heaped on Epstein. Moore was accused in the press of encouraging 'the cult of ugliness', Bolshevism, and worse besides. Commenting on the Leicester Galleries exhibition of 1931, *The Morning Post* declared, '[Moore] shows an utter contempt for the natural beauty

of women and children and in so doing deprives even stone of its value as a means of aesthetic and emotional expression'. The critic of *The Evening Post* wrote of one image of a Mother and Child that 'most people will hold it to be revolting as a representation of a woman and child, and ignoble as a work of art'. The hostile atmosphere aroused by his early work brought about Moore's resignation from the Royal College in 1931. Even in 1931, though, an anonymous critic for *The Times* was more perceptive: he wrote sympathetically of the special appeal the formal relationship between mother and child had for Moore, and added that the emotional strength of his work flowed out of the way in which he had transformed that formal relationship.

Looking back, we can now see that the technical and formal innovations of Moore's first sculptural phase (which ended with the Norwich *Mother and Child* of 1932) were attempts to widen the emotional range of his sculpture. Instead of treating the infant–mother relationship as a sight, or object of sentimental feeling, he tried to give expression to what the relationship felt like *from the inside*. Similarly, although he rejected glib, classical canons of beauty, his insistence on 'truth to materials' served to accentuate the association he wished to make between his great reclining women and the earth itself. In 1931 a writer in *The Yorkshire Post* perceptively commented of one such figure that it was like 'a Grampian landscape', and referred to its refusal to be separated from the terrestrial rock from which it was hewn. Moore was to underline these associations in later works by repeating again and again the peaking of the breasts and the bunching of the knees of the Ottawa *Reclining Woman* of 1930.

At the end of the first phase of Moore's career we are starting to feel the energy of his remembered response

29

to the craggy landscape of his native Yorkshire, and of earlier, more disturbing experiences too.

iii *Moore's Second Phase* (1932–39): Modernism, Surrealism, Neo-Romanticism

In the 1930s, Moore's work began to be transformed; it was as if he wanted to find, through the exploration of a new formal language, an iconography which would speak as powerfully to our times as that of the ancient gods had done in 'primitive' cultures. To do so, Moore turned increasingly away from direct imitation of 'primitive' sources, and drew deeply upon those indigenous romantic traditions which evoked the similarities between the body of a woman, ranges of mountains and hills, and the cathedrals. Hence that great series of reclining figures in wood, and stone, which came to dominate his work in the later 1930s. Through the sculptural exploration of this theme, Moore began to give expression to a new sense of the unity between man and the nature which environed him; a sense which did not deny the violation which man's technist triumphalism was wreaking against nature – but which endeavoured to reach beyond it, to offer a new image of reconciliation and harmony.

In 1932, Moore became first head of the new sculpture department at Chelsea School of Art, and in the following year he was chosen to be a member of Unit One, with which he exhibited in 1933 and 1934. Unit One was a group founded by Paul Nash and it included Barbara Hepworth and Ben Nicholson as members. The only common bond between the member artists was that they all felt they stood 'for the expression of a truly

contemporary spirit, for that thing which is recognised as peculiarly of today'. In fact, this was an odd position for Moore to adopt, given that there had hitherto been nothing conspicuously 'of today' about his work; indeed, it had up to that point seemed sprung out of a reinterpretation of tradition, and involved looking intently at the sculpture of ancient civilisations of the distant past.

Nevertheless, in the 1930s the focus of Moore's work changed dramatically; he was influenced by European Surrealism and the British abstract movement. He contributed to a major Surrealist exhibition held in London in 1936, but in retrospect we can see that his imagination possessed a poise, balance and, in the best sense, an *ordinariness* which the Surrealists lacked. On occasion, he might appear to have become interested in formal experimentation, for its own sake. During this time, indeed, he evolved many of the new sculptural conventions, such as joining the front and back of a figure with a hole, which were to become so important a part of his later work. Not all his work of this period is successful, or of enduring significance. As he himself came to recognise, there was something repetitive about the numerous stringed sculptures he made at this time. Nonetheless, it would be wrong to see Moore's work of the 1930s as a diversion from the main course of his development.

Modernist criticism has always tended to place an exclusive emphasis on the development of formal and technical means and to neglect consideration of the ends to which formal innovations are put. Whether or not Barbara Hepworth realised a pierced form before Moore, as her protagonists like to claim, the fact remains that plenty of punctured figures had already been produced on the Continent by Archipenko, Picasso,

Vantongerloo, Lipchitz, et al., long before. In fact, Charles Harrison is right in one respect when he writes: 'Moore was not himself responsible for a single substantial technical advance which could be seen as such in the context of modern sculpture as a whole.'[17] But then it is important to emphasise that great as Moore's technical achievement was, his greatness does *not* consist in his formal innovations.

Basically, Moore was not interested in the idea of avant-garde innovation as an end in itself; rather, formal devices were, for him, simply a way of bringing about such transformations and metamorphoses of natural form as might enable him to intensify the emotive content of his work. This content was often quite different from that pursued by the Continental innovators. 'My sculpture,' Moore himself said in 1937, 'is becoming less representational, less an outward visual copy, and so what some people would call more abstract.' But he added that this was 'only because I believe that in this way I can present the human psychological content of my work with greatest directness and intensity'.[18]

Take, for example, the *Mother and Child* of 1936, in Ancaster stone: it has sometimes been said that, in works like this, Moore was 'following the lead' of that biomorphism which Arp was pursuing in France. This may, or may not, have been the case, but it hardly seems to matter, for in this small work Moore achieved something Arp never did; this *Mother and Child* represents a radical reworking of the infant–mother theme as a subject for sculpture. It is quite different from, say, the nineteenth-century sculptor Dalou's treatment of the nursing couple as a sight or object of a third party's gaze; work which, today, we tend to regard as 'sentimental', or as evoking emotions which are not fully earned or

worked through in the forms themselves. Nor is this *Mother and Child* like Moore's borrowings from, say, the art of the Aztecs of ten years earlier. In this piece, Moore endeavoured to depict the relationship between child and mother from the inside: he has expressed that sense of mergence or fusion with the other which is an essential part of the experience of infancy, but which cannot be seen from the outside. The sculpture gives plastic expression to the child's point of view, or way of feeling.

It must be admitted, however, that not everything Moore made in the 1930s can be seen in this way: works like the upright *Mother and Child* of 1936, or, judging by the photographs, the *Reclining Figure* of 1937, have about them a now outdated chic. They seem to want to declare, first and foremost, that they are *modern* sculptures although their novel forms do not reveal any new content. This was, I think, especially true of the stringed figures Moore made in the late thirties: Moore himself later came to criticise their divorce from what he called 'fundamental human experience'; they are examples of the way in which the impact of modernism could deflect Moore from his true course.

In the late 1930s, Moore also used what were for him new formal means through which he infused the great theme of the reclining figure with fresh meaning. Nowhere is this more clear than in the great reclining figures – three in elm wood, and one, the Tate Gallery's *Recumbent Figure* of 1938, in Hornton stone – which Moore produced in those years. The idea of an identity between subject and object, woman and ground, which (as we have seen) had once been expressed through archaic (or, in Ledward's case, conventional) imagery and 'truth to materials' is now realised through forms themselves. By any account, the Tate's *Recumbent Figure*

must be reckoned among Moore's greatest master-
pieces.

Moore explained that the device of the hole enabled
him to make a space and a three-dimensional form
within a single object. As he pointed out, sculpture in air
thus became possible: the hole itself can be the 'intended
and considered form'.[19] But as the psychological force of
this new formal device may have stemmed from the fact
that the hole blurs the boundary between the object and
its environment, the punctured figure can no longer be
said to be contained by a limiting membrane, or skin,
separating inside from outside: the image of the 'Earth
Mother' is expressed not through the trappings of
anachronistic myth, but rather through the language of
sculptural form itself. Where the Victorians might have
evoked Demeter, Moore creates a figure which in its
very form is symbolic; which, in its physical presence,
fuses inner and outer and suggests the union between
the two.

Transformation is at the centre of Moore's art; and it is
this quality which differentiates him on the one hand
from the Victorian sculptors, and on the other from the
'avant-gardists': indeed, this idea of transformation
links Moore to that other great stylistic ecelectic, Picasso.
'Only Picasso,' the painter Graham Sutherland once
remarked, 'seemed to have the true idea of metamor-
phosis whereby things found a new form through
feeling.'[20] But 'transformation', in this sense, was a
romantic rather than a modernist idea; and Sutherland
admitted that what he admired in Picasso was a quality
he had already encountered in Samuel Palmer, whose
landscapes were also 'transformed' by imagination and
feeling.

I believe that the liberating force on Moore in the late
1930s was not his encounter with the Modern Move-

ment but rather *that great resurgence of English romaticism,* about which we are slowly beginning to understand more and more. As the clouds of war began to gather, the Continental avant-garde artists who had sought refuge in London left Britain, mostly for America. There was then a turning inwards on the part of British artists and a welling up of interest in the imaginative and romantic traditions of Britain's past, and a new sense of interest in her architecture, her landscape, even her reformed religion. The critic who perhaps understood all this best was, of course, that great opponent of modernism, Kenneth Clark, who became a patron of the work of Moore, Piper and Sutherland.

In the later 1930s, Moore no longer entirely lacked critical support, or understanding. As well as Kenneth Clark, from a rather different perspective Herbert Read became a friend and advocate. John Rothenstein, who was director of the Tate Gallery from 1938 to 1964, came to admire Moore's work too. Nonetheless, in the 1930s, many of the powers that then were in the art world were as hostile – if somewhat more reticent in voicing their judgements – as the popular press and the academic sculptors. John Rothenstein has recorded how, in 1939, the Contemporary Art Society acquired Moore's *Recumbent Figure*, carved the previous year. Apparently, Clark and he felt it was necessary to lobby every Trustee of the Tate, to ensure that they did not refuse the *Recumbent Figure*, as a gift from the Contemporary Art Society. Clark and Rothenstein were delighted, but somewhat surprised, when their efforts succeeded.

The ill-defined but influential British neo-Romantic movement with which all three were associated was characterised by a desire to reaffirm a sense of the British landscape and tradition at a time when these things were under threat. But it was not simply nostalgic or

escapist: on the contrary the artists who could be loosely grouped under this label were compelled by the threat of war, and later by the war itself, to elaborate a new vision of nature, injured and ravaged by man's activity, and yet still capable of nurturing and sustaining. The neo-Romantics tended either to discover the human spirit in the landscape, or to 'read' the landscape in terms of the human figure. Although this preoccupation had never before manifested itself in *sculpture*, it has a long history in the British romantic tradition, as we have seen in the case of Ruskin.

Moore had always blended human and natural forms. As we have seen, as early as 1931 one of Moore's *Reclining Women* had been described as like 'a Grampian landscape', though perhaps Pennine would have been more accurate. Moore's reclining figures of the late 1930s, at once injured and fractured, and yet vividly expressing a new sense of wholeness and unity, arose out of, and reached beyond, the fears and hopes of those trouble times. Freed of the inhibiting restraints of modernity, and yet nourished by its formal and technical innovations, Moore was able to begin to achieve his full stature. He benefited from what Robin Ironside called 'a return to a freedom of attitude more easily accessible to the temper of our culture, a freedom of attitude that might acquiesce in the inconsistencies of Ruskin but could not flourish under the system of Fry'.[21] For, as Ironside put it, 'the best British art relied upon a stimulus that might be ethical, poetic or philosophic, but was not simply plastic'.[22]

iv *Interlude*: The War (1939–45)

The second phase of Moore's development ended with the creation of *Three Points* in 1939/40 and the outbreak of war. In 1940, his London studio was bombed, and he moved to Perry Green, near Much Hadham in Hertfordshire, where he lived until his death in August 1986. For three years, Moore made no sculptures, saying later that with the outbreak of war he had 'felt it was silly to make a large sculpture'; but he drew instead. 'Drawing,' he said, 'is everything.' Moore had drawn since he was five or six years old, and he was as fine a draughtsman as he was a sculptor. When he was appointed an official war artist by the War Artists Advisory Commission, he produced his remarkable series of 'shelter drawings' of Londoners sleeping under blankets in the tube; and another lesser, but, I believe, underestimated group of miners at work on the coalface, near his home town of Castleford.

The imagery of the shelter drawings was of such a kind as was bound to move Moore; mothers and children lay swathed and swaddled in rugs and blankets in long tunnels which stretched into the distance like the bowels of the earth itself. The scene was tinged with menace, and a sense of potential destruction; and yet, equally, it was suffused with a feeling of maternal intimacy. The wrappings and blankets which intertwine among the figures suddenly seem like shrouds; yet these suggestions of death are overcome, and, in the drawings, the final impression can be best described as one of stoic harmony.

Though redolent with observed details, Moore's war drawings of figures somehow engulfed within the protective bowels of the earth relate immediately to his sculptural attempts to blend human and natural form, to

see 'figures in the landscape and a landscape in the figures', as John Read once put it.[23] The shelter drawings were indeed to influence the forms of Moore's draped female figures for many years to come. In their mysterious, even mythological quality they confirm that Moore's sensibility thrived in a neo-Romantic climate. The statuesque nursing mothers and all the imagery of mergence in the drapes and blankets and swaddling bands indicate that the roots of this mystery are to be found not so much in religious experience as in the infant–mother relationship. Moore seems to suggest that the ambiguities of this first relationship are repeated in the adult's relationship to the sustaining environment.

As a war artist, Moore evoked the suffering of a nation, not as an historic event, but as an image. He mingled nurture, sustenance, containment – and war. His swaddling bands are also shrouds. His figures are majestic in their misery and slumber like gods. In the shelter drawings, and also in the contemporaneous drawings of miners at the coalface, he mythologised, and therefore made comprehensible the experience of ordinary people.

Moore's war drawings are among the finest ever produced in Britain. In them he made use both of his acute perceptual observation and of his powers of intense imaginative transformation. Yet here we should emphasise that, in 'avant-gardist' terms, they are almost a step backwards from the work Moore was doing in the late 1930s. These drawings do *not* function primarily through the metaphors of form: Moore reveals himself confident enough to have reached back into the reservoir of classical convention which was anathema to the Modern Movement. Erich Neumann, the Jungian psychoanalyst who made a study of Moore's work,

rightly argued that, in these drawings, the motif of intertwining drapery has 'the same formal role of uniting mother and child that the stone once had'.[24] The folding drapery in which Moore swathed his figures evokes the ghostly world of Victorian classicism: stylistically, these works have strong affinities with, for example, the drawings of Frederick Leighton. If the comparison sounds strained, compare the draped studies Leighton made for his *Fatidica* with *Shelter Scene: Two Swathed Figures*, or with *Woman Seated in the Underground* of the same year.[25] There is, however, a vacuity and a blandness about Leighton's 'art for art's sake' classicism, while Moore's work is charged with a depth of feeling at once deeply personal, and national.

Moore's return to sculpture in 1943 was marked by his Northampton *Madonna*, commissioned by Canon Walter Hussey for St Matthew's Church in Northampton and completed in 1944. In its magnificent aloofness the *Madonna and Child* recalls the hieratic serenity of the English Romanesque. As always in Moore, there is an attempt at affirmation, but this first work of his maturity is an affirmation stripped of the rhetoric of the future, rooted in the sense of the past. No clearer instance could be given of the fact that for Moore the shock is the shock of the old. The past, returning, is what affronts us, rather than the present. Kenneth Clark rightly pointed out how this work makes nonsense of the claim that Moore's imagination was essentially primitive, or indelibly attached to a negative response to the classical tradition in Western art.

In the *Madonna*, the hopeful dignity that Moore had managed to find even amidst the barbarity of global war contrasts strongly with the vision of a sick and mutant humanity expressed through Francis Bacon's *Three Studies for Figures at the Base of a Crucifixion* (belonging to

39

the Tate Gallery), made at almost exactly the same time. Bacon's forms express a brutal degradation of the Western religious impulse, an incapacity in the wake of the war to perceive anything in man except evil, and bandaged corruption. Moore's *Madonna*, though possessing the freshness and vitality which results from the direct carving of the stone, is solemn, silent and serene; she gazes out on the world with a classical repose, authority and equilibrium, and with an expression which Moore himself has described as one of 'aloof mystery', all of which are rare in twentieth-century art, though not in earlier centuries in the West. And yet she, too, is resolutely secular – a human mother with a human child. In a sense, we are compelled to choose between these two antithetical visions of ourselves. We must decide whether, in a world apparently deserted by God, we prefer to see our fellow human beings as sacks of mutilated, spasm-ridden muscle; or as creatures still capable of composure, dignity, and profound spiritual strength.

Some have seen this piece as a 'reactionary' work, a step backward from the punctured sculptures of the 1930s which contain and define space. But I believe that Eric Newton was right when he wrote that the mother and child harmonise unexpectedly with their neo-Gothic setting, 'because the statue is so designed in scale that the space it occupies seems to have been waiting for it'.[26] The Northampton *Madonna* and the transept of the church of St Matthew almost seem to constitute a single work.

On this whole period of Moore's career, I agree with Grey Gowrie when he writes that in an age when patriotic art had been, with few exceptions, synonymous with bad art, Moore's work 'celebrated England by making her travail universal'.[27] Moore's work during

the war established his reputation far beyond the enclave of those concerned with abstract and avant-garde art. As Gowrie again puts it, 'until the 1960s, when a new urban aesthetic took hold, Moore was almost everywhere regarded as the most powerful artist since the death of Turner'.

v *The Public Sculptor* (1946–59)

In 1944, the year in which Moore completed his North-ampton *Madonna*, Herbert Read published a monograph on the sculptor in which he argued that, unlike the poet or the painter, a sculptor was necessarily 'driven into the open, into the church and the market-place, and his work must rise majestically above the agora, the assem-bled people'. Britain had artists great in potentiality, 'and none greater than [Henry Moore]'. But, 'the people must be worthy of the sculpture. . . . genius can never reach a final scope until sensibility is awake in the people.'[28] In fact, even as Read wrote these words they were becoming redundant: when Read revised the text four years later, he was to omit them. Instead, Read described the way in which Moore's *Three Standing Figures*, sited in Battersea Park, was commanding the admiration and respect it deserved from those who viewed it.

By 1948, indeed, Moore's work had entered a new and very public phase; there was a response to his sculpture from the agora, the assembled people. This was a time when there was tremendous interest in British art, and in that peculiarly British cultural achievement which had its roots in the neo-Romantic revival of the 1930s and 1940s and which, unlike futurism and modernism,

could never have led to fascism. There was also a great optimism in our national cultural life: having won the war, we had also won the cultural leadership. There was a sense of the recreation of a new world. If it was the period of Bowlby, of Winnicott and of the Festival of Britain, it was also the period of Moore's great public sculptures. As so often with Moore, the psychological and the historical mingle and interchange.

The fact was that, in the years immediately following the Second World War, through the war drawings, the Northampton *Madonna*, and the intelligent patronage of the British Council, Moore's reputation grew not only in Britain, but throughout the Western world. During the 1940s and 1950s, Moore created some of his best-known pieces: the great carved stone *Memorial Figure*, of a reclining woman, situated in the gardens of Dartington Hall, Devon; the bronze *Family Group*, now in front of the Barclay School in Stevenage; the *Draped Reclining Figure*, of 1952–3; the famous *King and Queen* of the same time; the *Harlow Family Group* of 1954–5; and the vast UNESCO *Reclining Figure* in travertine stone of 1957–8. While continuing to produce some neo-abstractions, based on organic forms (especially bones), Moore emerged in the 1950s from the rarefied climate of the avant-garde to fine new sculptural forms through which to express the bravest ethical aspirations of the post-war world.

Like the nineteenth-century Romantics, in the late 1940s and 1950s Moore began to reveal a growing obsession with classicism: in fact, it might be said that he was one of the last great artists whose imagination was structured in terms of this romantic–classical opposition: just as the Pre-Raphaelite revolution of the 1850s issued forth in a Victorian High Renaissance, so Moore's 'primitivism' of the 1920s developed into his classicism

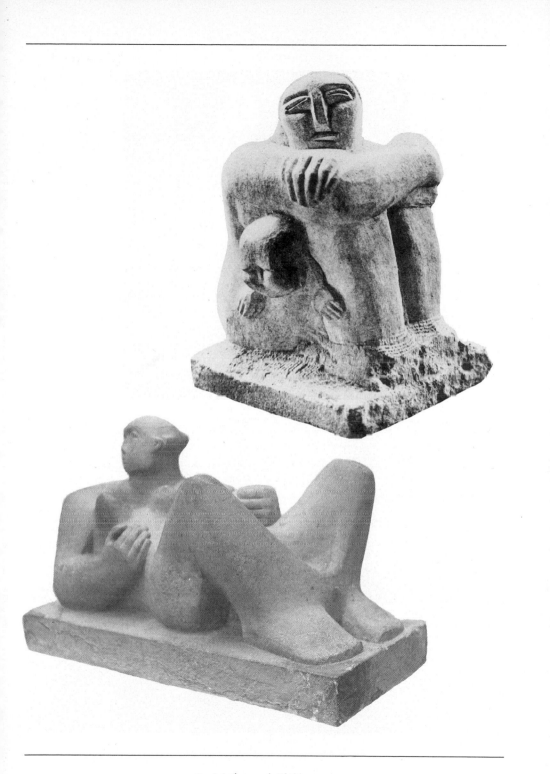

1a *Mother and Child,* 1922
1b *Reclining Woman,* 1930

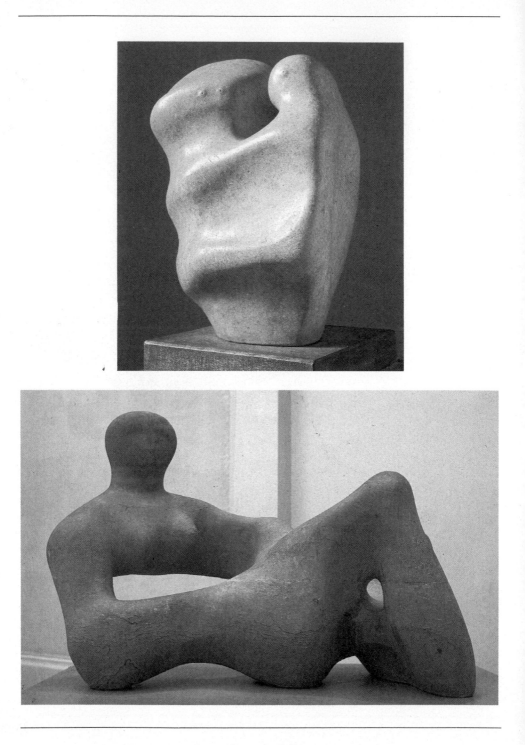

2a *Mother and Child, 1936*
2b *Recumbent Figure, 1938*

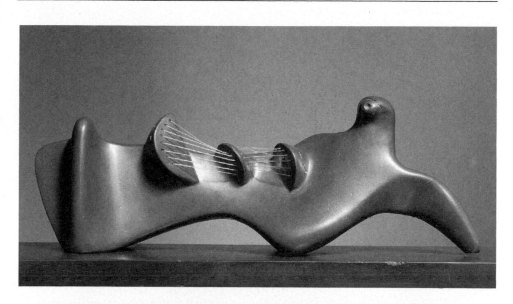

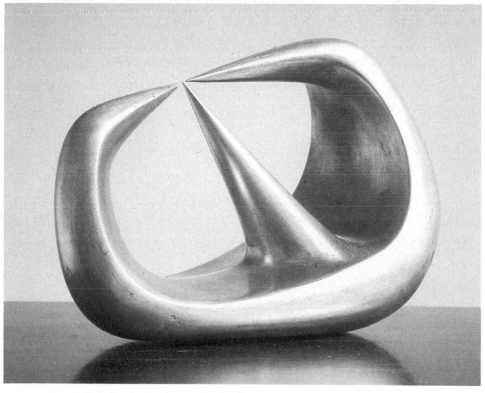

3a *Stringed Reclining Figure, 1939*
3b *Three Points, 1939–40*

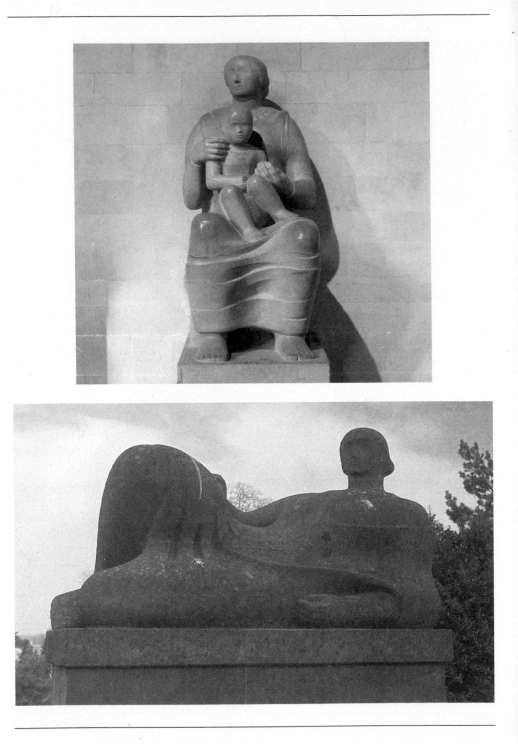

4a *Northampton Madonna, 1944*
4b *Memorial Figure, 1945–6*

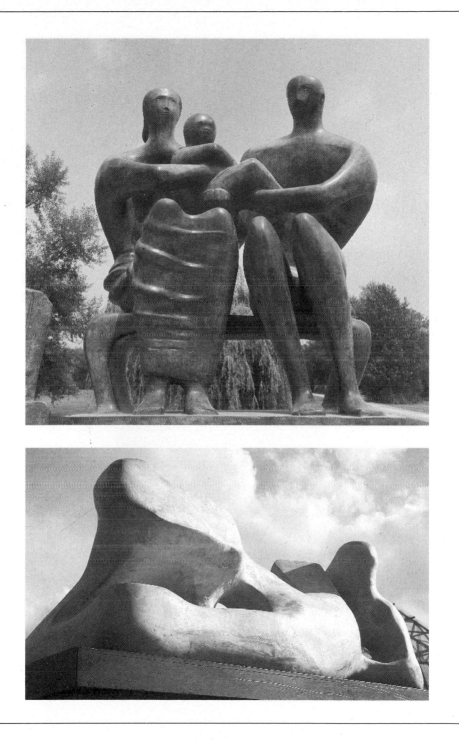

5a *Family Group, 1948–9*
5b *Reclining Figure, 1959–64*

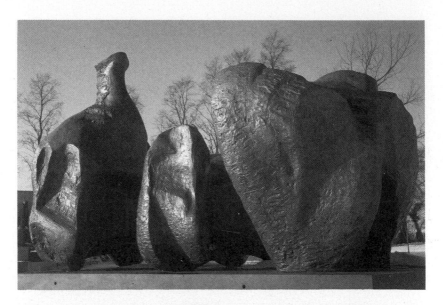

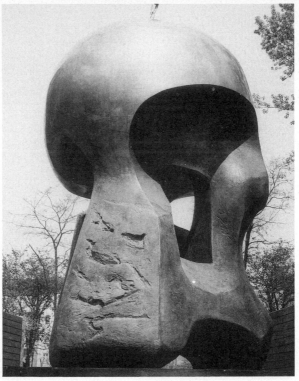

6a *Three Piece Reclining Figure, 1961*
6b *Nuclear Energy, 1964*

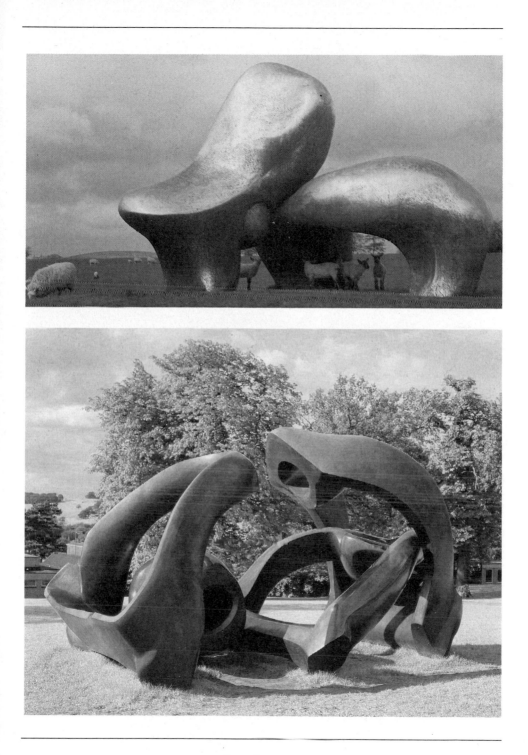

7a *Sheep Piece, 1971–2*
7b *Hill Arches, 1972*

8a *Two Sleepers on the Underground, 1941*
8b *Women Winding Wool, 1949*

of the 1950s. His immediate post-war sculptures, like the Dartington *Memorial Figure* and the extraordinary elm-wood *Reclining Figure* of 1945–6 incorporating an explosive armoured head within an undulating female figure, or the ambitious family groups, all exhibit a poise and an equilibrium for which the word 'classical' seems appropriate; this association became explicit after Moore's trip to Greece in 1951, which resulted in works like the overtly Hellenic *Draped Reclining Figure* of 1952.

This change in Moore's work was associated with a change in his conception of the sculptor's role in the world, and also with a profound change in his working practices. Moore benefited greatly from the foresight and patronage of agencies like the British Council and the Arts Council of Great Britain, who successfully promoted his work and his reputation throughout the Western world. He, in his turn, saw it as his duty to serve on committees and public bodies dedicated to the advancement of art, especially of sculpture, in the modern world: he began to resemble those nineteenth-century classical artists, like Eastlake and Leighton, who also played a large part in public life.

Interestingly, Moore also began to return to those working practices which he had begun his life by rebelling against. Bronze became his favoured material; he often modelled pieces on a very small scale and his works were subsequently enlarged into working models and full-blown sculptures by assistants and craftsmen. The importance of 'truth to materials', he explained, had been exaggerated; the very idea of truth to a metal as versatile as bronze was without meaning. What mattered most was the imagination of the artist and his heroic aspiration to embody his imaginings in matter.

It is in this period of Moore's work that we find the family groups, the kings, the queens, the fallen

warriors, as well as many reclining figures and mothers and children, more serene and classical in spirit than some of those before and after them. This period has been much criticised, but what is not recognised by the critics is that here was an artist, perhaps the only artist of the time, whose vision was really interacting with that of the people. Arguments about relevance are here confounded, for people find as relevant what they long for. The last thing a man in prison wants is art about prison.

This is the light in which we should see Moore's mythic figures, not as fantasy, but as an affirmation of imaginative life, of nature, and indeed, of human creativeness itself. It is here that the Greek element is inescapable. There is something about the Moore of this time which combines the best elements from the medieval world and from classicism, not in the postmodernist sense of mingling codes, but in Walter Pater's sense of imaginative reason.

The public phase of Moore's work ended with his gigantic UNESCO *Reclining Figure* which, exceptionally for this stage in his career, Moore carved for the organisation's headquarters in Paris during 1957–8; the completion of this sculpture, in Alan Bowness's words, marked a watershed in Moore's development.[29] No other piece Moore had made had been conceived on such a gigantic scale: in front of this work one has to admit that it has a weight which is crushing. But one also realises what Kenneth Clark meant when he argued that, 'in Moore's work there is always at the back of his mind the memory of Michelangelo and the Greeks'.[30] Moore, Clark believed, was driven by an 'urge to create an almost classical ideal of noble, placid female beauty', but, within a few years, his work was once again to be convulsed by a new invigorating and transforming tide of romanticism.

44

Much has been made of the 'innovatory', even revolutionary, qualities of British sculpture in the 1960s; but there is no doubt in my mind that the truly great and original work of this era was in fact made by Henry Moore. In 1959, Moore endeavoured to sum up thirty years of exploration of the reclining female figure as both a nurturing and consoling body and a landscape. He did so in another elm-wood *Reclining Figure* which he worked on over a five-year period; this work is, in effect, a drawing together of all that Moore felt about this theme. It embraces us with the sort of experience we gain from the Northampton *Madonna and* the church which encloses and envelops her. This great sculpture is a culmination, and a consummation, of all that Moore had learned up to this date about the image of the reclining female figure as a symbol of consolation, reconciliation, and renewal: in her strange, undulating forms, she is at once woman, landscape, and cathedral. The quiet strength of the *Reclining Figure* – its serenity, authority and silent equilibrium, encompassing us with all the power of a great secular cathedral in wood – contrasts with the fact that while he was working on it his conception of the figure was undergoing fundamental change.

vi *The Last Phase* (1959–86):
 A Revaluation

In the late 1950s and subsequently, the monumental grandeur of the finest public pieces gave way to an expressive vision, the complexity, originality and scale of which no other sculptor in the post-war era has begun to approach. This later work has received very little

critical evaluation or interpretation. Moore's monumental vision was widely held to be irrelevant in a world of obsolescence, consumer durables, admass and information processing, as was his continued use of traditional means and materials of the sculptor: modelling and carving, marble and bronze. It is time to redress the balance now that we are increasingly ambivalent about the merits of technology and planned obsolescence.

In other sculptures Moore made around the time of the *Reclining Figure* of 1959–64, his epic female figures began fragmenting, splitting, and cleaving into their several parts. Alan Bowness was the first to argue that 1958 marked the end of Moore's third phase as a sculptor primarily conscious of his social role, and the beginning of a new and more personal 'late period'. 'From this date forward,' Bowness wrote, 'Moore has seemed more inclined to please himself, exploiting all the possibilities of working on a grand scale that were now open to him as a successful sculptor, indifferent to fashion and caring little about what other people might think.'[31]

Nothing demonstrates this change in Moore's sensibility more vividly than what happened to his reclining female figures. The great rocks and cliff faces of breasts, torso and mountainously raised knees were severing and drifting apart, as if some strange geological convulsion was erupting from the lower strata of Moore's imagination itself. Moore described the process in a characteristically matter-of-fact way:

> I realised what an advantage a separated two-piece composition could have in relating figures to landscape. Knees and breasts are mountains. Once these two parts become separated you don't expect it to be a

naturalistic figure: therefore you can
justifiably make it like a landscape or a rock.[32]

Even so, these changes led to some of the strangest of
Moore's sculptures based on the female body, sculp-
tures which seemed menaced by a constant threat of
disintegration, even disappearance. The illusion seems
about to fade into the materials and it is redeemed – only
at the last moment – by the cohesive and unifying power
of Moore's formal arrangements.

It was not just chance which led to the awesome
immensity of *Nuclear Energy* of 1964. The terrifying 'skull'
of this work seems to resemble that helmeted head which
lay explosively, yet silently, within the elm-wood reclin-
ing figure of 1945–6. For the work of Moore's maturity
offers more than a new aesthetic experience. Both *Nuclear
Energy* and the shattered and shattering earth mothers
express a disturbing vision Moore had of what was
happening to the world. It was as if Moore was exploring,
and, in formal terms, somehow containing, the cataclys-
mic forces which threatened both the sustaining environ-
ment of nature and human culture itself.

In Chapter Five I analyse the two great themes of the
mother and child, and the reclining figure, in Moore's
work in terms of the ideas of one of his contemporaries.
Following D. W. Winnicott, I will suggest that we see
these sculptures in terms of the infant's simultaneous
identification with and separation from the environment
his mother provides. I also relate these two poles of
infantile experience to the two poles of aesthetic experi-
ence, that of the beautiful, which is separate from us,
and that of the sublime, which engulfs us. Moore was
the first sculptor who – in these late works – was able to
give sculptural expression to the engulfing sublime, as
opposed to the separated beautiful object apart from us.

At its best, Moore's sculpture offers much more than a new kind of aesthetic experience, or a new view of woman; for his great reclining figures seem to speak of the sustaining environment of nature, and indeed perhaps even of culture itself. His shattering earth mothers seem to express his vision of what was happening to the sustaining environment of nature – and indeed to that of human culture itself. If we look back over Moore's work we cannot help but notice that – with the exception of his unsuccessful stringed figures which were partly derived from things seen in the Science Museum – he eschewed the whole range of mechanical and technological imagery. He revived and replenished an indigenous romantic traditon, but he did so in a way which was at once fully sculptural, and yet new to sculpture.

Like all great art, the best of Moore's sculptures cannot be tied down to a single interpretation; and yet one of their many meanings may be that they offer us an aesthetic of ecological harmony. When we lose sight of our sense of unity with nature, then there is a danger of destroying both ourselves and nature itself. Moore often spoke of a love of organic form which is self-evident in the works themselves, of 'the growth of branches from the trunk each finding its individual air-space, the texture and variety of grasses, the shape of shells, of pebbles'.[33] Such concerns were Ruskinian rather than modernist. Moore did not set nature aside from human culture. He even retained an 'organic' view of human culture itself. 'Culture,' he once said, 'as the word implies, is an organic process. There is no such thing as a synthetic culture, or if there is it is a false and impermanent culture.'[34] Moore's late reclining figures resist, though they acknowledge the threat of disintegration of nature and culture. They are perhaps the closest things to the great Gothic cathedrals (which Ruskin so dearly

loved) that a secular age, like our own, can hope to produce.

There are those who have seen an irony in Moore's later years; he seems, to some, to have become the paradigm of that post-Renaissance sculptor which he had reacted against when he began his career. The chisels and tools, though never abandoned altogether, gave way to models, maquettes, pointing–up machines, the labour of assistants, and the work of the bronze founders. Moore also entered into a new fruitful *rapprochement* with the sculpture of Greece, openly celebrating a classical dimension of his imagination, which had perhaps never been as submerged in his work as he sometimes claimed. At times there was, inevitably, a loss of that immediate energy and vitality which, as a young man, he had so resolutely pursued. And yet it must also be admitted that what he now loses in terms of 'truth to materials' and immediacy of handling, he often seems to gain in terms of the terrifying power and scale of his imagery. Nowhere is this more evident than in the great bronze reclining figures of the early 1960s, which rank among the finest works Moore ever made. His imaginative defiance of the modern world is now expressed on a more epic scale than that which fidelity to the chisel would have allowed; and yet, in a strange sense, these figures, at once fractured, and yet unified, are dependent on what he learned when 'truth to materials' seemed to be all.

There were, of course, those who, from the beginning, endeavoured to produce sculptures which in terms of both the way they were made, and what they revealed, were reflective of the 'synthetic' culture Moore despised. In his *Concise History of Modern Sculpture*, Herbert Read remarks that 'Henry Moore remains within the same formal tradition as Michelangelo', but,

despite his admiration for Moore, he stresses the rise of an alternative tradition of 'free-standing three-dimensional works of plastic art', which we continue to call sculpture, but which, he says, 'are in no sense "sculpted" or even "moulded" '. He explains that they are 'built up, like architecture, or constructed like a machine'.[35] Let us, in the spirit of Marx, call them 'lightning-rod' sculptures!

Such work, we might say, was that which had failed to perceive the lessons of Vorticism, work which proceeded out of faith in, and collusion with, the modern world – rather than a grand refusal of it. And yet, from our perspective in 1990, how successful has that collusive tradition been? It is surely time to reassess Moore's grand refusal of modernism and its implications, for Moore above all artists of the twentieth century encapsulates an alternative tradition and an alternative vision, humane rather than mechanistic, ecological rather than technological. Partly in order to prepare the way for such a reassessment, we will close this chapter on Moore's artistic career by focusing briefly on his work as a draughtsman.

vii *Moore as a Draughtsman*

Moore's drawing is of interest not only because he happens to be one of this century's greatest sculptors. Rather, his drawing is something *sui generis*: quite independently of his stature and achievement as a sculptor. Moore is also a draughtsman of genius, one of the finest British draughtsman of this century, indeed of any century. No one has come closer than Moore to creating a new aesthetic in which perception and

imagination are reunited through a response to natural form which is at once perceptually accurate, and involved with the most profound of symbols. The works on paper Moore produced in his later years had less and less to do with what had been happening (or failing to happen) in his sculpture. His drawing manifests a life and a development which is entirely its own. I am convinced that even if we did not have any of his major sculptures, the extraordinary cycles of drawing Henry Moore produced during the war and from about 1972 will eventually come to be recognised as one of the most remarkable aesthetic achievements of recent times. In his late work his line manifests that quality of tender authority which one associates with the old age of genius: it is legitimate to compare Moore's late drawing with that of Michelangelo in the last years of his life.

Henry Moore consistently advocated drawing, both as a necessary ingredient in life, and as an essential component in the training of sculptors. 'From the earliest time I can remember,' he once wrote, 'drawing was the activity I enjoyed most.' Moore described drawing as 'a part of learning: to draw is not to turn people into artists, just as you don't teach grammar to turn them all into Shakespeares'.

But when Moore knew that he wanted to become a sculptor, he realised that all the great sculptors from the past whom he admired had been great draughtsmen. He always advocated figure drawing for the sculptor, in particular. 'The construction of the human figure, its tremendous variety of balance, of size, of rhythm, all those things make the human form much more difficult to get right in a drawing than anything else.' Getting it right matters for the sculptor, for Moore has repeatedly expressed the view that all sculpture is ultimately rooted in knowledge of the figure.

William Morris thought that figure drawing was good for those involved in ornamental work, and he gave similar reasons. 'There is,' Morris wrote, 'only *one best* way of teaching drawing, and that is teaching the scholar to draw the human figure: both because the lines of a man's body are much more subtle than anything else, and because you can more surely be found out and set right if you go wrong.'

Predictably, Henry Moore's life drawing at the Royal College of Art in the 1920s was remarkable. It manifests that 'full cylindrical roundness' which knowledge of his sculptural work might lead one to expect. I recall, especially, a drawing of a woman's buttocks of 1923 (now in the Art Gallery of Ontario). Moore recalled that William Rothenstein, then Principal of the Royal College, had seen and admired this work. As we see from his early life drawings, Moore had a tremendous sense of the construction of the human figure, and a great feel for its variety of balance, size and rhythm. All this he was able to express with exemplary economy of line; he can evoke the massivity of a woman's back with just a few marks in brush or charcoal. But it must be said that (unlike the Slade empiricists) Moore never regarded drawing as solely, or even primarily, the pursuit of exact verisimilitude.

Moore has always believed in the value of making copies from other works of art. Copying has been notoriously out of fashion this century: and yet it is the only way in which an artist can fully acquaint himself with the techniques, conventions, and traditions of the past. Without these, he has no language with which to confront the object, in the world, or in his mind. The studies Moore made from Giovanni Bellini's *Pietà* in 1975 demonstrate that for him copying was anything but a mechanical process: unlike student copies made for the

purposes of study alone, these drawings are themselves responses by one master to the work of another. They quiver with Moore's affective reactions to Bellini's great work. Something similar can be said of the intimate and yet exact copies of earlier works which Moore made in his later years. Moore's drawing from Courbet's *La Source*, for example, though faithful to the original, also reverberates with Moore's own concerns and pre-occupations, which can be traced right back to those Royal College life drawings.

But tradition was not the only way in which Moore sought to inflect the evidences reaching him through his eyes. It was, in fact, many years since he had even tried to draw directly from the nude model. There have been times when he has explored a variety of graphic 'auto-matism', letting his drawn imagery simply 'come' from his inner world. Even when not working in this way, Moore has made use of memory and imagination as much as perception in the creation of his drawn images. But he returns, as if for replenishment, and to avoid personal mannerism, to anatomical and natural form.

Thus after his daughter was born in the 1940s, Moore made a remarkably immediate and tender series of drawings of Irina, his wife, and the child. These images seemed to owe little, if anything, to his previous investigations of the mother–child theme. Similarly, as we have already observed in Part iv of this chapter, the shelter and mining drawings made use both of acute observation and of imaginative transformation. But they belong neither to the world of reconstituted impressions, nor yet to that of fantasy. They constitute a vital third area of experiencing.

When he returned to drawing in the early 1970s, after a long gap, he plunged into a subject, directly observed from nature, that he had not handled for half a century:

sheep with their lambs. The beautiful 'Sheep Sketch-book' was drawn in 1972, at a time when the presence of packers in his studio and grounds (crating works for the great Florence show) made sculpture itself impossible. The sheep could not be more sharply observed: and yet, without sentimentalisation or projection, Moore has made them his own. There is something monumental in many of the ewes suckling lambs. This strangely 'subjective' sort of scientific objectivity is reminiscent of Stubbs's great pictures of mares with their foals.

Among the drawings of Moore's last decade we find familiar themes: there were, for example, some masterful new sheep drawings; reclining women; mothers with their children; women winding wool; clasped hands; naked figures reminiscent of Cézanne's bathers; and mountain landscapes which recall those qualities of Turner's which Ruskin loved.

Moore's late drawings, indeed, impress on the observer the continuity between Moore's imagination and that of John Ruskin. Ruskin was fired by an image of mountainsides as the sensual bodies of those women he had never known. Moore, too, had the sort of imagination which mingled geology and anatomy, the figure and its environment; but in his case, the transformation worked the other way round. It could be said that, for Moore, women's bodies became those Pennine ranges he deserted when he made his home in the rolling slopes of the Hertfordshire countryside.

But Moore's drawing is not just nostalgia. On the contrary, he is a great master draughtsman, whose work, even at the end, had undiminished aesthetic authority: in his old age, he seemed to have recaptured something of the freshness of vision we associate with childhood. Perhaps this is not so surprising. For Moore, drawing was ever a means of learning: he was always

experimenting with means and techniques. Some of the later drawings were made using black ballpoint, charcoal, white wax crayon, black chinagraph, and bluegrey watercolour wash in a single image! It is striking, too, but not so surprising that late in his career, when sculpture was no longer physically possible for him, Moore should have turned to the medium of stained glass in which to reinterpret the reclining figure theme.

In his late excursions into drawing and stained glass, Moore showed that he could still learn something new from the art of the past, which he loved. In his stained glass he recaptures the confident, classical serenity which had been disturbed by the romantic explorations of the fourth phase. His landscapes showed he was still, in old age, able to look upon nature with the freshness and originality of eye that we associate with youth rather than old age.

Why we do so, however, is hard to say. Few young artists in the 1970s and 1980s were looking at nature today as acutely, or as imaginatively, as Henry Moore. Appropriately, his great drawing, *Sheep grazing in long grass No.1*, of 1981 was also used as the cover of a book called *Second Nature*, published by Common Ground. This organisation was seeking to 'forge new links between the practice and enjoyment of the arts and the conservation of landscape and nature'. The intimacy and modesty of much of Moore's late drawing is as deceptive as that of William Blake's poems. I believe these works authoritatively display that kind of aesthetic based on an imaginative response to natural form which our 'synthetic culture' (as Moore called it) requires, if it is to be redeemed from itself.

After Moore

i Moore and Recent Criticism

In recent years, art critics and the institutional art world
have been – to say the least – reticent about Moore's
achievement. The view repeatedly presented in the art
history books is that Henry Moore's greatest work was
done in the 1930s – or, in some accounts, in the 1920s
when, it is incorrectly said, he was a 'pioneer' of the
Modern Movement in art. According to this account,
what happened after the war represented a sad decline,
when ideas worked out much earlier were inflated on a
grander and grander scale. Appraising Moore's career in
the *Guardian* (1 September 1986), after his death, Norbert
Lynton wrote, 'Time will show which was his greater
achievement, his life or his art.' The art press is even
more grudging; Moore is regularly viewed, if at all, as a
dinosaur whose concerns are of little moment to sculp-
tors, or to anyone else, in the modern world.

Such writers are reacting against the traditional and
conservationist dimension of Moore's achievement. As
Kenneth Clark realised, whatever Moore may have said,
he was always a British, romantic artist *before* he was a
pioneer of the Modern Movement. Moore owed far
more to the tradition of Ruskin than to that of Wyndham

Lewis. Like Constable's and Turner's before him, Moore's vision involved as much resistance to, as acceptance of, modernity. And it is for this reason that critical opinion from the 1960s onwards has increasingly turned against Moore.

Kenneth Clark had once said that if one man had to be sent to the moon to represent our civilisation, he would opt for Henry Moore. Clark and Herbert Read had been the great champions of Moore in the 1930s and 1940s. It was Moore, the neo-Romantic, who embodied the critical ideas of Clark. Herbert Read, in retrospect, seems somewhat confused about Moore. While his admiration for Moore was unremitting, he was also an unequivocal supporter of the Modern Movement, with his advocacy of 'lightning-rod' sculptures. Nonetheless, his hope that Moore would eventually find a public worthy of him was realised after the war, to a greater extent than either he or Clark could at one time have dared to hope.

Moore's art was then in tune with the time, with its astringent optimism, with the idea of national reconstruction. His high humanist ethics, his belief in the family and his desire for a new kind of spiritual harmony also found an echo in the national consciousness. Increasingly, it seemed, his work enjoyed a popular response outside the narrow parameters of the art world, as well as admiration and patronage within.

What happened next to Moore's reputation is as disconcerting as it is remarkable. It is best illustrated by the fact that, in the late 1950s, Moore's then recent work was attacked by John Berger, who was advocating a 'social realist' position through his column in the *New Statesman*. Berger accused Moore of making 'Piltdown sculptures'.[1] He wrote, too, of the tendency in some of Moore's work for the imaginative to disappear, with the result that Moore's only subject became 'the inert mater-

ial he had in his hands'. There is some truth in this criticism, but it was a truth Moore himself recognised in the 1950s and was striving to deal with, admitting that in the past he had exaggerated the doctrine of 'truth to materials'.

Yet just when Berger was criticising Moore's abstractness, he was also denigrated as a 'second-rate' artist by the American formalist critic and protagonist of abstract painting, Clement Greenberg. From this time on, Moore's standing with the 'agora' (of Herbert Read's terminology) increased every day; but his reputation within the art world faded away, and it did so not just within one particular tendency, but, as it were, across the board. The descendants of Berger's criticism in the 1950s, today, are probably the feminist and political critics: their contempt for Moore knows no bounds. For example, one feminist critic has publicly described Moore as 'sentimental', a 'minor artist', who perpetuates 'stereotypes of women'. Anthony Barnett used the opportunity of a television programme on Henry Moore in 1988 to take a 'stroll round the British class system', while at the same time presenting Moore as a money-grubbing social climber, who betrayed his class and his talents, snubbed old friends, and ended up chasing wealth and public honours while his art fell into a lamentable decline.

Alan Bowness commented that the film appeared to have been made by someone who just did not understand how an artist's mind worked.[2] One could indeed concede to critics that in the 1960s and 1970s, particularly in some of the pieces hauled up outside public buildings, some of the figures testify to the fact that they were made by Henry Moore – and little else. And even that is not always strictly true; many later carvings were pointed up by craftsmen. For all their smooth sleekness,

they lack the taut energy of the earlier, directly carved pieces. But the weaknesses of some pieces are often in contrast to the strength and vitality of others, about whose powerful and questing vision they tell us nothing.

Barnett's film can safely be forgotten because it did not even begin to approach Moore's vision, practice or achievement as an artist. More disturbing to those concerned about Moore as an artist, however, has been the vociferous criticism of Greenberg. He accused Moore of tastefulness and 'attachment to the past'.[3] The final effect of a Moore sculpture, Greenberg wrote, 'somehow discounts the actual presence of modernist calligraphy and detail, to leave one with the impression, hard to define but nevertheless definite, of something not too far from classical statuary'.[4] Needless to say, for Greenberg, this was a singular fault. Truly new and modern sculpture, Greenberg insisted, 'has almost no historical associations whatsoever – at least not with our own civilization's past – which endows it with a virginality that compels the artist's boldness and invites him to tell everything without fear of censorship by tradition. All he need remember of the past is cubist painting, all he need avoid is naturalism.'[5] Greenberg announced that he could even agree with the opponents of modernism: 'I have had my fill of Henry Moore and artists like him.'[6] Thomas Hess was even more outspoken: he attributed the 'inflation' of Henry Moore's reputation to 'the achievement of British intellectuals, who, at the end of the last war, needed *chefs-d'école* who would be: native, yet Continental in style; metaphysical for metaphors, yet natural (i.e. connected with a country garden of the soul); verbally Socialist in human sympathies, yet aristocratic in stance'.[7]

The remarks about 'a country garden of the soul'

reflects back on the man, and the culture, from which it emanated; but this American view of sculpture was channelled back to England by one of Moore's erstwhile assistants, Anthony Caro, who was as dismissive of Moore's imagery, style and working practices, as he was of his stance. 'My generation,' Caro wrote in 1960, 'abhors the idea of a father-figure, and [Moore's] work is bitterly attacked by artists and critics under forty when it fails to measure up to the outsize scale it has been given.'[8] Under the direct influence of Greenberg, and of American abstract painting, Caro went on to advocate and to produce an urban, synthetic, constructed, and radically abstract sculpture, made out of brightly painted industrial components – usually steel. Caro's sculptures, wrote Michael Fried, one of the artist's American critical protagonists, 'reject almost everything Moore's stand for'.[9] As is well known, Caro himself quickly became the father figure of successive waves of fashionable sculpture in Britain, united in little except their repudiation of Moore: indeed as Moore's stature grew and grew in the world at large, the art world came to pay less and less attention to him, and he was largely ignored by those in a position to be influenced by him.

By 1964, Herbert Read had begun to have doubts about lightning-rod sculpture. He had begun to realise that this tradition had produced no masterpieces, and had, in effect, ceased to be sculpture at all. 'One must ask a devastating question: to what extent does the art remain in any traditional (or semantic) sense *sculpture*?' He pointed out that from its inception in prehistoric times down through the ages and until comparatively recently, sculpture was conceived as an art of solid form, of *mass*, and its virtues were related to spatial occupancy. 'It was for his restoration to the art of its characteristic virtues that Rodin was praised.' But, even

then, sculpture had become wholly linear, 'a scribble in the air'. 'Virtually everything,' wrote Read, 'one must say, has been lost that has characterized the art of sculpture in the past.'[10] The sculpture of the late 1950s seemed to Read simply to accost the spectator with aggressive spikes; but, somewhat desperately, he consoled himself that it could still be considered sculpture because it stood in some sort of relation to the organic world, and to a modern sense of the *terribilità* of the post-war world.

But Read must have known that, even as he wrote, these sentimental links with sculpture proper were being washed away by sculptors themselves. His book illustrated, but did not discuss, the sculpture of Anthony Caro – linear, metallic, technological, radically abstract – but without even a hint or a trace of organicism or *angst*. Caro's work of the 1960s and 1970s may have lacked many of those physical properties and aesthetic qualities which have characterised sculpture for all but a quarter of a century, in a history which stretches back across countless millennia, but from the point of view of that history, far worse was to come. Only now, and only fitfully, is criticism – and sculpture – beginning to extricate itself from the shallow modernism which has for so long afflicted us, and to rediscover the true virtues of the work of Henry Moore, his humanism and his transformations of matter and form.

ii *Sculpture after Moore*

The real tragedy was that when Moore died in 1986, his achievement, and the originality of his 'late phase', were but little regarded by younger sculptors. Most prefer to

trace descent from Anthony Caro, who had declared himself opposed to all anthropomorphic or 'natural' form. He dispensed with traditional sculptural techniques, like carving and modelling, in favour of the placement of preconstituted, industrial elements (like I-beams, tank-tops, and sheet steel) joined together by welds. He abandoned plinth and pedestal, and showed no concern with mass, volume, the illusion of internal structure, or the qualities of his materials. His art is essentially planar and pictorial, rather than volumetric and sculptural. His wife frequently covered the steel elements with coats of brilliant household paint so the metal looked like plastic or fibreglass.

Such work had little in common with anything that had previously been regarded as sculpture. Caro first came to public attention in Britain with his Whitechapel exhibition of 1963, which *The Times* greeted with the headline, 'Out-and-out originality in our contemporary sculpture'. It was a year in which it seemed that some radical cultural transformation was about to take place in Britain. With the Profumo affair, the old men of British politics were swept off their plinths; Harold Wilson, the Labour leader, spoke of the 'white heat of the techno-logical revolution'; and there was much talk of the nationalisation of steel. On all sides, one could feel a cult of newness. The nation was shaken by the *Honest to God* affair: the Bishop of Woolwich caused a scandal with a popular book about 'Death of God' theology in which he argued against the anthropomorphic conception of deity, and recommended bringing God off his pedestal to reconstitute him as the 'ground of our being'. Caro's work was nothing if not of its time: it reflected the superficial, synthetic, urban, commercial, American values which dominated the 1960s.

Caro had, perhaps incautiously, declared that sculp-

ture could be anything, but in his own work has always retained a sense of stability, weight and permanence in his structures of welded industrial elements, and an aesthetic decorativeness in the arrangement of his component parts. From where we now stand this looks almost conservationist. His rebellious pupils and followers took what he said about sculpture more literally than he intended, reducing sculpture to the mere placement of unworked and formless matter, or any other substance or activity at all. Barry Flanagan and Nicholas Pope reduced the art to the placement of barely worked materials. Others started digging holes, taking photographs, and even walking on holiday and calling that sculpture too. Gilbert and George became fashionable by declaring their own persons as 'Living Sculptures' – and the Tate bought a videotape of them getting drunk. The 1980s saw a return to 'objects', rather than events, or performance, as sculpture; but the much heralded 'New Sculpture' has not been associated with a fundamental repudiation of the anti-sculptural tendencies of the 1960s and 1970s. Indeed, at the time of a major survey of today's New Sculpture at the Hayward, in 1984, one eminent, if none too rigorous, critic wrote in the promotional literature: 'Sculpture is what sculptors do.' He added that no other definition was possible . . . Needless to say, Michelangelo would have disagreed.[11] The much-vaunted 'freeing' and broadening of sculpture of recent years had in fact seen the dissolution of the 'freed' works into a world of activities and objects which are not sculpture, and which indeed appear to be devoid of any aesthetic qualities.

The object-based 'new' sculpture relies largely on flippant collaging of improbable materials – car doors, broken refrigerators, used tyres, etc. 'Sculptors' like Tony Cragg and Bill Woodrow consciously refuse

aesthetic form; their work involves no identifiable skills, and offers no vision of man, woman, or beast. Although the 'New Sculptors' receive seemingly limitless institutional promotion, they intend a continuing insult on tradition – upon which originality depends. Their work is not worthy of serious concern or attention, and if those who govern the institutions of contemporary art possessed any aesthetic judgement, it would simply not be shown.

Back in 1962, Moore himself had said, 'We're getting to a state in which everything is allowed and everybody is about as good as everybody else.' He warned that both artists and public were going to get bored. 'You've got to be ready to break the rules but not to throw them all over unthinkingly.' He added, 'Someone will have to take up the challenge of what has been done before.' In 1986, somewhat late in the day, Caro appeared to have recognised this; perhaps sheepishly but nonetheless bravely he returned to figurative sculpture.

There are others, however, who have seriously engaged with the challenge of what has been done before. Glynn Williams was an accomplished carver before he became caught up in the silliness of the 1960s, when he worked in fibreglass, and with mixed-media 'environments'. All that he now regards as a dark night of his sculptural soul. In the 1970s, he returned first to traditional materials like wood, and later stone; and then abandoned construction in favour of carving. Finally, towards the end of the decade, he re-immersed himself in tradition, embraced illusion, and produced an exceptional series of formally original sculptures, the subjects of which were mothers and children, human hands, acrobats, nude male figures, and even a modern *pietà*. Williams's vision has all the freshness, originality, and *joie de vivre* of a blind man who has recovered his sight.

Unlike the 'New Sculpture', which excites only cynicism and contempt beyond the confines of the art world, Williams's work has been greatly in demand for shopping precincts, theatre foyers, hospitals, and housing estates throughout the country. As in Moore, there is in Williams an interest in the qualities of materials and a desire to create new sculptural forms. Like Moore, Williams brings these materials and forms into contact with a world of human values, through 'moments of illusion'. Roger Scruton has pointed out that in Williams's sculpture, as in Moore's, 'there is an affirmation of the human form which is also a recognition of the spiritual need which speaks through it. The plastic values of these sculptors are not separable from their normal sense: they touch the human form as something sacred, whose meaning transcends the matter that conveys it.'[12]

The brashness and vigour of Williams's carving immediately evokes that sense of vitality and vigour sought by Epstein and the young Henry Moore. Yet Williams is not an 'expressionist'; in only one of his sculptures, *Shout*, 1982 has he endeavoured to express overwhelming emotion. This carving is a contemporary variation on the theme of the *pietà*, with echoes of Epstein's *Night* and his TUC Memorial. All Williams's work is imbued with a sustaining sense of the tradition of sculpture, and the great 'touchstones' of the past: unlike the New Sculptors of the 1980s, he has grasped the truth of T. S. Eliot's dictum that there can be no originality except on the basis of tradition.

At its best, Williams's work is (like most great art) deeply conservative, and profoundly radical: the last few years have seen a series of carvings which combine depth of human feeling with astonishing formal ingenuity, and a profound responsiveness to the heritage of

the sculptural tradition. In all these respects, the work Williams is now doing is reminiscent of what Henry Moore was attempting in the 1930s – and it tends to produce a similar sense of bewilderment among those in the art institutions with narrow, bigoted, modern, or 'post-modern' tastes. For example, a few years ago, I endeavoured to persuade the Tate Gallery to buy *Stone Rise East*, but I was advised that the staff at the Gallery could not share my views concerning the quality of Williams's work – and this was at a time when they had been purchasing such trash as Bill Woodrow's 'Car-Door, Ironing-Board, Twin-Tub, with North American Indian Headdress'.

But Williams is not an isolated instance: in the 1980s, he organised virtually annual exhibitions in Cannizaro Park, Wimbledon, which brought to the attention of the public the work of his then colleagues, associates, and students from the Wimbledon School of Art, which thereby established its credentials as one of the few remaining centres of sculptural excellence in this country. Among those whose work has stood out in several of these exhibitions is Lee Grandjean, a carver whose principal medium is wood. His sensibility is more poetic than Williams's, but nonetheless thoroughly sculptural. In works like *Willow*, 1985, his figures have achieved a sinuous yet taut expressivity, which is his own – and which yet seems to contain echoes of the great Gothic wood-carvers of East Anglia, where he lives.

Nor should it be thought that the sculptural tradition is confined to Wimbledon, and those associated with it![13] There are many individuals, who, throughout all the nonsense of the last thirty years, have endeavoured to keep alive that challenge of what has been done before. I have been impressed, for example, by the

sculptures of Fenwick Lawson, especially by the *pietà* in beech wood and bronze which has been exhibited in the cloisters of York Minster. This work may not be a masterpiece: but it is an attempt – and a powerful attempt – to revive, sustain and extend the sculptural tradition (of which Michelangelo was the greatest exemplar) in which the masterpiece remains a possibility. I believe it is *that* tradition which the institutions and agents of patronage should be endeavouring to foster; until they begin to grasp this fact, we are unlikely to see sculptural achievement on the scale on which Henry Moore was able to realise it, in part at least because of his support from the institutions and agents of public patronage.

Conclusion:
Interpretations

In this concluding chapter, I want to look first at one of Moore's persistent themes, the mother and child relationship. In so doing, I will draw what strikes me as an illuminating comparison between the work of Moore and that of the psychologist D. W. Winnicott. I will attempt to show how for both Moore and Winnicott it is in and through the changing relationship between the mother and the child that the need arises for a space of 'transitional objects', those cultural artefacts which are both separate from us (and in that sense objective) and yet expressive of human feeling and meaning (and so also subjective). Moore, in his sculpture, explores the subjectivity of the child in its relation to the mother. But he also treats the mother as landscape, as environment. And this, in turn, gives Moore's work an ecological as well as a cultural significance. In the concluding section, I will show how Moore's aesthetic can be regarded above all as an ecological aesthetic.

i *Moore, Winnicott and the Mother and Child*

There was a moment to which D. W. Winnicott referred more than once in his writings when he found himself

bursting out at a meeting of the Psychoanalytic Society, 'There is no such thing as a baby.' 'I was alarmed to hear myself utter these words,' he was to comment later, 'and tried to justify myself by pointing out that if you show me a baby you certainly show me also someone caring for the baby, or at least a pram with someone's eyes and ears glued to it. One sees 'a nursing couple'.[1]

But Winnicott later went on to draw conclusions from this moment of insight which went beyond what could be immediately seen with the eyes. Winnicott began to write of a 'condition that it can be assumed exists at the beginning of the individual's life in which the object is not yet separated out from the subject'.[2] For those not used to psychoanalytic jargon, 'object' means 'other person' – usually, from the baby's point of view, the mother. Winnicott says that, from an observer's point of view, the baby may seem 'to be object-relating in the primary merged state'; but he adds that it has to be remembered that, at the beginning, the object is a 'subjective object', as distinct from an 'object objectively perceived'.[3]

Now, more than any other psychoanalytic writer, Winnicott respected 'the delicacy of what is preverbal, unverbalized, and unverbalizable except perhaps in poetry'. And yet when he attempts to describe such things as the infant's experience of a 'subjective object', we feel that language is being strained to its limits. If only there was another, more visual, way of expressing these sentiments and ideas! Consider, for a moment, Moore's (Ancaster stone) *Mother and Child* of 1939. Looking at the sculpture in the light of Winnicott's ideas, it is hardly necessary to offer any further commentary on it.

Some may think that there is something forced, or fortuitous, about this comparison between one of

Winnicott's theories about the nature of the infant's experience in the infant–mother relationship, and a particular sculpture by Moore. That is understandable. But I hope to be able to dispel at least some of the doubts.

I am not going to use a body of psychoanalytic ideas derived from Winnicott's theoretical writings as a means of 'interpreting' Moore's sculpture, and saying what it is 'really' about. Such 'applications' of psychoanalytic ideas to art were always misplaced; today, they are quite obsolete. Art is not a symptom. Indeed, I am reminded that, in his clinical practice, Winnicott grew increasingly sceptical about the value of making clever interpretations to his patients – even if they happened to be right. Something similar applies in the appreciation of art, too: the clever interpretation – and I'm not only thinking of psychoanalytic interpretations – can be an impingement, something which distracts from, or even detracts from, a deeper aesthetic response. The good critic, too, knows when to withhold clever interpretations. What I want to do runs, I hope, a little deeper than that.

I want to suggest that there are vital resemblances between Winnicott's pioneering psychoanalytical insights, and the vision which Moore has expressed through his great sculptures and drawings. Take the 1949 drawing of *Women Winding Wool*. It is one of our century's very greatest drawings. As the wool passes from one woman to the other, the lines through which the two figures are drawn seem to merge and fuse inextricably. And yet each remains separate: monumentally so.

I think we can say, without doubt, it is a drawing Winnicott would have appreciated had he known it, if only because of the importance which imagery of mothers, string and mergence has in his own work. It is an image apt in both form and content as an illustration

of the relationship between two quite distinct but also intimately related bodies of work which I now wish to sketch.

At first sight, Winnicott's achievement does not seem to have much in common with that of Henry Moore. Winnicott was born in 1896 into a prosperous middle-class family: his father, a sweet manufacturer, became Lord Mayor of Plymouth. Winnicott himself studied biology, became a doctor, and specialised in paediatrics. He soon started an association with Paddington Green Children's Hospital, which was to last for forty years. Winnicott also underwent training with the British Psychoanalytical Society, and, in the late 1930s, began to emerge as a prominent figure within the psychoanalytic movement. Outside it, too, he was to become known for his radio talks, and popular articles about mothering and babycare. As Masud Khan, one of Winnicott's editors, once put it, he displayed, rather similarly to Moore, 'a militant incapacity to accept dogma'. Although he always acknowledged his debt to Melanie Klein, when the British Psychoanalytical Society was torn by theoretical and organisational controversies, after the last war, Winnicott aligned himself neither with the Kleinians nor with the followers of Anna Freud.[4] Rather, he became a leading light of the so-called 'Middle Group'. This should not be taken as a sign of weakness or woolliness. Rather, Winnicott began to formulate and to explore highly original ideas about the nature of the infant–mother relationship, which were a challenge to existing psychoanalytic orthodoxies. They also led him far beyond the nursery and the consulting room to a tentative new view about the nature of human creativity, and indeed of culture itself.

Moore once said that of the three recurring themes in his work (the Mother and Child, the Reclining Figure

and the Interior/Exterior forms), the Mother and Child had always been the most fundamental obsession.[5] The mother–child relationship was certainly the most fundamental of Winnicott's concerns. All that Winnicott said and wrote was rooted in his extraordinary empathy for the mother and her child, an empathy which, of course, was based on exceptional empirical experience: it was estimated that sixty thousand mothers with their children consulted Winnicott at Paddington Green. Winnicott broke decisively with Freud's concept, inherited also by Klein, of the baby as an auto-erotic isolate, driven by the need to experience pleasure through the reduction of instinctual tension within a hypothetical 'psychic apparatus'. Winnicott simply did not accept the idea that a 'one-body relationship' precedes the 'two-body relationship': he stressed that in the beginning 'the unit is not the individual, the unit is the environmental-individual set-up'. Winnicott described the infant as being enveloped within, and conditional upon, the holding environment (or mother) of whose support and succour he becomes only gradually aware. 'I would say that initially,' he once wrote, 'there is a condition which could be described at one and the same time as of *absolute independence* and *absolute dependence*.'[6]

Winnicott thought the infant made his first contact with reality through what he called 'moments of illusion'. Through such moments, the infant gradually became aware that he was not everything: that he was contained by a limiting membrane, or skin, and possessed an inside. These 'moments of illusion,' Winnicott thought, arose when the infant's fantasy and external reality coincided – most notably when the mother offered her breast at precisely the moment when the infant desired or imagined it. In this way, the infant

acquires the illusion that there is an external reality which corresponds to his capacity to create. Later, Winnicott thought, it was the mother's task to take the infant through a process of 'disillusion', associated with weaning, during which the infant gently relinquished omnipotence, and learned there was an outside world which was not his own creation.[7]

But Winnicott spoke of a continuing need in the developing and growing child for a space which could not be clearly categorised as inner or outer, as fantasy or reality, a continuing need, if you will, to make use of 'subjective objects'. Thus he was led on to his famous theory of 'transitional objects and transitional phenomena'. He began to describe 'the third part of the life of a human being, a part that we cannot ignore, an intermediate area of experiencing, to which inner reality and external life both contribute'.[8]

Winnicott emphasised the child's use of 'the first possession' – that is those rags, blankets, cloths, teddy bears, etc. – to which young children commonly become attached. He saw that, for the child, such 'transitional objects' belonged to an intermediate area between the subjective and that which is objectively perceived. Winnicott regarded play itself as a transitional phenomenon. Clinically, he made use of these ideas through such techniques as the 'squiggle game', in which he communicated with a child through an open-ended process of transformation of the given. Winnicott would draw a line on a piece of paper; the child would turn it into something; then he would complete a line, or squiggle, made by the child . . . and so on.

Winnicott talked a good deal about the importance of not challenging transitional objects and phenomena, of not impinging upon them. One simply had to accept the paradox they offered. He repeatedly drew a comparison

between these ideas about transitional objects and Christian doctrines about the eucharist. How can the host appear to be ordinary bread and yet be wholly the body of Christ? The controversies concerning transubstantiation arose from the attempt to resolve a paradox of which there can be no resolution.

Towards the end of his life, Winnicott became increasingly aware of the wider cultural and artistic significance of his ideas. He came to talk about what he called 'a potential space', which, he said, arises at that moment when after a state of feeling merged in with the mother, the baby arrives at the point of separating out the mother from the self – and the mother simultaneously lowers her degree of adaptation to her baby's needs. At this moment, Winnicott said, the infant seeks to avoid separation 'by the filling in of the potential space with creative playing, with the use of symbols, and with all that eventually adds up to a cultural life'.[9] He pointed out that the task of reality acceptance is never completed: 'no human being is free from the strain of relating inner and outer reality'. The relief from this strain, he maintained, is provided by the continuance of an intermediate area which is not challenged: the potential space, originally between baby and mother, is ideally reproduced between child and family, and between individual and society, or the world.

Winnicott saw the potential space as in direct continuity with the play area of the small child, 'lost' in play. He felt it was retained in the intense experiencing that belongs to the arts and to religion and to imaginative life of all kinds. Indeed, he described the potential space as 'the location of cultural experience'.[10]

Winnicott's ideas about the 'potential space' were certainly tentative. *Playing and Reality*, the book in which he puts them forward, is not entirely resolved. We know

that Winnicott was working on his formulations about the 'potential space' immediately before his death and still felt he had not got them quite right. Nonetheless, I believe Charles Rycroft was absolutely right when he said, in 1972, that Winnicott's concept of a transitional reality mediating between the private world of dreams and the public, shared world of the environment was 'perhaps the most important contribution made to psychoanalytical theory' since the Second World War.[11] He was also right, however, to say that this insight was not entirely original – as it appeared to be synonymous with what poets and artists described in terms of the imagination. The association of Winnicott's psychological ideas with artistic vision is not fortuitous. As Madeleine Davis and David Wallbridge point out in *Boundary and Space*, an excellent introduction to Winnicott's work, 'Underlying Winnicott's writing is a sense of balance and proportion – an aesthetic sense often seems to take a visual form, just as his favourite method of communication in his work with children took a visual form in the Squiggle Game.'[12]

Moore was always a sculptor for whom 'form experience' is paramount, but as we recognise this, and the 'aesthetic sense' underlying Winnicott's psychology, we ought also to recognise that the experience to which Moore's sculptures invite us go beyond the formal to affirm the meanings and values which make life worth living. In saying this, however, we must be cautious, for, as Winnicott once put it, 'Content is of no meaning without form.'[13]

Moor was a profoundly original sculptor: but his originality was rooted in – to use a word which again had a special significance for Winnicott – the *ordinary*. Moore is proof of one of the most significant insights of the English school of psychoanalysis: namely that there is

no *necessary* link between artistic creativity and neurosis, nor between genius and psychosis.

I would suggest that there is a continuity between the security and happiness of Moore's childhood environment and the particular nature of his adult sculptural vision. The anecdote Moore often repeated about the young Moore massaging his mother's back has all the over-polished feel of a screen memory; but it seems to stand in for a range of early experiences which informed far more of his adult sculptural activity than just the single sculpture to which he referred in telling it. Once, a Jungian analyst, Erich Neumann, sent Moore a book he had written about his work. Moore read the first chapter, and then laid the book aside – not because he felt it was nonsense but rather because, as he put it, 'it explained too much about what my motives were'. He shared the understandable – but almost certainly erroneous – fear of many creative people that, as he put it, 'If I was psychoanalysed I might stop being a sculptor . . . but . . . I don't want to stop being a sculptor.'[14]

On the mother-and-child theme, however, Moore himself wrote in 1981 that it 'poses for the sculptor the relationship of a large form to a small one, and the dependency of the small form on the larger. Its appeal lies particularly in its expression of two basic human experiences: to be a child and to be a parent.'[15] Winnicott, too, differentiated between the way in which the infant–mother relationship appeared to an independent observer, and the way in which it felt, as it were, from the inside. Moore had outraged taste in 1931 because, in a fully sculptural way, he was making that shift. He was moving away from the naturalistic spectacle of an infant suckling at the breast – as offered by so many nineteenth-century salon sculptors – towards work which

had greater continuity with the 'subjective objects' of the potential space.

One of the most fundamental ways in which Moore did this concerned not his imagery, but his practical affirmation of the doctrine of 'truth to materials'. As we have seen, Winnicott associated 'transitional' phenomena with the notorious arguments surrounding the status of the bread and wine in the eucharist and the degree to which they were, or were not, imbued with the Real Presence to become the actual body and blood of Christ. In recent aesthetics, a parallel concern revolves round the relationship between the image in a work of art and the physical materials used for its realisation. Like Gaudier-Brzeska, Moore originally felt that the nineteenth-century sculptors had tilted things too far by trying to handle, say, marble as if it really was flesh. The myth of Pygmalion was wrecking sculpture's transitional qualities and turning it into mere mimesis, or an adult version of infantile magic-making. Moore, by contrast, celebrated the conspicuous and undeniable stoniness of Mexican carving. 'I began believing in direct stone carving,' he was to say later, 'in being true to the material by not making stone look like flesh.'[16] But, by the 1950s, Moore himself was saying that as a young man he had exaggerated the argument of 'truth to materials'.[17] If this was taken too far sculpture could – and in the hands of others *did* – become dominated by the material to such a degree that the image disappeared altogether and the transitional paradox on which good sculpture depended was again lost. The artist must offer a 'moment of illusion' which cannot be challenged, within which a block of stone is at once both a real and unmistakable block of stone and, simultaneously, a mother with her child, or a couple locked in a kiss that is a sculpture.

Some of Moore's formal experiments during the 1930s were to affect his sculpture for the rest of his working life: others, as we have seen, proved to be culs-de-sac. One of the most fruitful was also among the most simple: that is, the hole, or, as Moore describes it, 'the penetration through from the front of the block to the back'. Moore has said that the making of the hole was, for him, a 'revelation'; having the idea to do it involved 'a great mental effort'.[18] Predictably, Moore's holes have been subjected to silly psychoanalytic interpretation. David Sylvester, who really should have known better, once associated them with female sexual organs.[19] But I do not think that, even unconsciously, Moore intended to evoke a mood of genital – or indeed any other – kind of excitation. Nor, of course, do these holes represent a point of entry into the figure. They represent, rather, a dissolution of the distinction of interior and exterior.

This interest in the fusion of interior-exterior forms takes another guise in Moore's work: that is in his lifelong obsession with the idea of one form enclosing another. As a student, he was fascinated by the suits of armour in the Wallace Collection, which reminded him of 'the shell of a snail which is there to protect the more vulnerable forms inside'.[20] In his sculpture, such playing with such forms has, he said, 'led sometimes to the idea of the Mother and Child where the outer form, the mother, is protecting the inner form, the child, like the mother does protect her child'. But note how in the *Reclining Figure*, 1945–6, the 'armoured' form is in fact the interior one.

As we have seen, in the 1930s Moore began to produce a stream of stringed figures, which Moore himself looked back on somewhat dismissively as being divorced from 'fundamental human experience'.[21] But, in this context, we might mention Winnicott's essay on

string. In this essay, Winnicott suggested that its joining capacities meant it had a symbolic meaning for everyone, but he also discussed the case of a small boy who made exaggerated and repetitive use of string as a way of expressing his denial of separation from the mother. The union between the forms in the stringed sculptures has just such a sterile and obsessive feel.

Interestingly, immediately after making the stringed figures, Moore created another psychologically curious, but sculpturally unsatisfactory, work which he called *Three Points*. 'This pointing,' he explained, 'has an emotional or physical action in it where things are just about to touch, but don't.' He associates this – among other things – with an early French painting, 'where one sister is just about to touch the nipple of the other' – but doesn't. 'It is very important that the points do not actually touch,' Moore says. 'There has to be a gap.'[22] If the stringed figures were obsessive, even perverse, denials of separation, here separation seems to me to be equally stultifyingly insisted upon. Those works which are formally more successful involve neither the denial of separation, nor yet the frozen assertion of it, as it were, in perpetuity. Rather, they present us with formal equivalents for a space which exists, yet cannot exist: a potential space.

After *Three Points*, when Moore temporarily abandoned sculpture because of the war, he produced, among other works, the famous shelter drawings. Moore's drawing techniques, as much as his use of sculptural materials and forms, reveal the importance of transitional experience to his art. From a very early age, Moore drew, and drew brilliantly, from life. But, early on, he also developed a method he called 'transformation' drawing – rather like a one-person version of the squiggle game. He described it as working with no

preconceived problem to solve, with only the desire to use pencil on paper, and make lines, tones and shapes. Moore found that at a certain point, imagery would begin to crystallise, and a sense of meaning and order would arise seemingly from the process of drawing itself. When he came to make his drawings of the sleepers on the platforms of London tube stations during air-raids, he made use of both his acute perceptual observation and his powers of intense imaginative transformation.

The imagery of the protective bowels of the earth, the engulfing cloak of the mother, rugs and blankets, which are at one moment warm covering, and in the next, a shroud, was all certainly there to be seen in the underground. But it also suggested to Moore his most intimate concerns – his interest in a space between mother and child, free from the terrible impingements of the world.

Will Grohmann has written well about these drawings. He says that it is almost always women that Moore drew, women 'reclining, or more rarely seated women, mothers with their children, and where the women have children, they automatically assume the stature of madonnas through the immensity of their responsibility'. He speaks too of 'countless wrappings, stretching out in endless rows, at bottomless depths'.[23] There is no need to labour the parallel here between Moore's cloths and blankets and Winnicott's transitional objects.

After the Northampton *Madonna*, Moore's astonishing series of mature works began to flow. Intriguingly, the birth of his own child, relatively late in his life, appears to have been one of the factors which encouraged him to realise a theme he had been thinking about for many years – a family group. It was as if he was asking – as even Winnicott finally got round to doing – 'What is father's role in all this?' But the mothers and

children, and also the great reclining figures in stone, elm-wood, and bronze, also continued.

Moore was very well aware of the way in which his great love of landscape had influenced the making of these figures. He once explained that landscape 'has been for me one of the sources of my energy'. This, of course, is rare among sculptors. Moore's sculptures are usually best seen in the natural landscapes – nowhere better than in the fields round his home at Perry Green in the midst of the Hertfordshire countryside. Very often, Moore relates a piece to the morphology of the landscape where it is situated, for example, in the great carved stone reclining memorial figure he cut for the grounds of Dartington Hall where the raised knees echo the hills. But the relationship he proposes between figure and landscape can be more radical than that.

Early on, Moore associated his reclining women with the earth itself, and his belief in 'truth to materials' accentuated and drew out the association. From 1959 to 1964, Moore tried to sum up thirty years of exploration of the reclining female figure as both a nurturing and consoling body and a landscape, in the great *Reclining Figure*. It is a consummate expression of all he knew about the theme at the time he made it. Its quiet contrasts with the fact that, during the years he worked on it, his conception of the figure was undergoing cataclysmic changes. As we have seen, other sculptures he made around and after this time show how his epic female figures were fragmenting, cleaving into their several parts, as if convulsed by some geological upheaval.

What then are we to make of this extraordinary series of late reclining figures? Winnicott argued that the infant's emotional experience tends to split the mother in two. He distinguished between the 'object mother',

who is the specific object of the infant's affections and excited instinctual needs, and the 'environment mother', whose holding, sustaining and providing provides the ground of the infant's 'going on being' before he becomes a separate person. These two poles can be related to the two poles of adult aesthetic experience – that is, to the sort of defined, limited and formal experiences we describe as 'beautiful', and to the engulfing, suffusing, or oceanic kinds of experience, which have traditionally been given the label 'sublime'. The sense of the beautiful has something to do with the object mother and the sense of the sublime has something to do with the environment mother. The sublime – with its sensations of engulfment – is always tinged with terror, as Edmund Burke recognised: with a threat of the annihilation of the self, and the subsuming into another. Prior to Henry Moore, the experience of the sublime was more associated with, say, cathedrals, or viewing actual landscapes, or certain kinds of painting and music.

In closing this section, I want to offer a far-flung excursus. Moore often spoke about the 'universality' of the mother-and-child theme. And yet, if we look at the art of the past, we find that it is far from ubiquitous. In Western art, mother–child imagery only achieves any prominence with the arrival of the Gothic style, and the cult of the Virgin Mary, in medieval France. Indeed, the mother–child theme begins to come into its own with the rebuilding of Chartres cathedral, which housed the most famous relic of Our Lady – the actual tunic she was supposed to have worn at the time of the Annunciation. The cult of the Virgin Mary was associated with the architectural and aesthetic efflorescence of European Christendom. Intriguingly, within a hundred years or so, the actual representation of Our Lady has become increasingly intimate, even playful. Truth to materials,

and formal novelty, certainly thrived – not just in great cathedrals, but even in details. For example, carvers made ivories of Our Lady and her child which follow, seemingly naturally, the curve of the elephant's tusk. But gradually, the period of the great Gothic cathedrals came to an end; emphasis shifted in representations of the real mother and child towards the image of the *pietà* – of a woman, old before her time, who weeps over the bleeding face of her increasingly human son.

I have written in *Theoria*[24] and elsewhere of the crisis which secularisation and, subsequently, industrialisation caused for the arts, and of how their effects were to seal over that playful, potential space, where subjective and objective can freely mix. These things led to the domination of human social and productive life by the Reality Principle. 'The Reality Principle,' Winnicott once wrote, 'is the fact of the existence of the world whether the baby creates it or not. It is the arch enemy of spontaneity, creativity, and the sense of Real . . . The Reality Principle is an insult.'[25]

Our century has been marked by the intrusion of this Reality Principle even into art itself, by the destruction of those moments of illusion which art can still offer. At the Hayward Gallery recently Moore's great *Reclining Figure* of 1959–64 stood opposite an enormous, volumetric cube of fragments of wood and detritus, put together by one of the most fashionable of the New Sculptors, Tony Cragg. Cragg's work is just stuff. Matter. Signifying nothing. In a way, this juxtaposition calls for a decision: a decision between the search for the secular circumstances which can sustain a potential space, in which creativity and culture remain possible; or the continued domination of our lives by the tyranny of the Reality Principle.

I have suggested strong parallels and continuities in

two very different sorts of vision: in Winnicott's psychology, and in Moore's sculpture and drawings. Both Winnicott and Moore have been concerned with the intimate interaction between the mother and child, and with the significance of those moments of transition, transformation, and illusion, where imagination and reality meet. The prototype of all such moments is surely that in which the mother offers her breast at the moment when the child wants it, thus strengthening, in him, the feeling that there is an outside world which corresponds to his capacity to create. From these distant beginnings, there followed, in both Winnicott and Moore, a vision of culture, indeed of man's relationship to nature, itself. There is no better way of tying up the continuities between them than by quoting Winnicott's view about artists:

> They do something very valuable for us,
> because they are constantly creating new
> forms and breaking through those forms only
> to create new ones. Artists enable us to keep
> alive, when the experiences of real life often
> threaten to destroy our sense of being alive
> and real in a living way. Artists best of all
> people remind us that the struggle between
> our impulses and a sense of security (both of
> which are vital to us) is an eternal struggle
> and one that goes on inside each one of us as
> long as our life lasts.[26]

Unfortunately, what Winnicott says is not true of all artists, but it is true of Moore, pre-eminently so.

ii *An Ecological Aesthetic*

I never saw the famous exhibition of Henry Moore's sculpture that was held in 1972 in and around the Forte di Belvedere, overlooking the city of Florence. I did, however, visit the exhibition, 'Henry Moore and Landscape', held at the Yorkshire Sculpture Park in West Bretton, a few miles from Moore's birthplace, a year after his death. The park is situated just a few miles from Castleford, where Moore was born. With its rolling slopes, formal gardens, sweeping vistas, and great lake, it seemed to me to provide an incomparable setting for a memorial exhibition to the greatest British artist of the twentieth century.

At the centre of the exhibition sat the King and Queen, the strange, emblematic figures, in which Moore himself said he wanted to express 'the concept of power in primitive kingship'. At the bottom of the slope beneath them was *Hill Arches*, a colossal bronze of 1972, suggesting the entangled and fractured forms of an enfolding Pietà, or the skeleton of a hill. And, all around, nearby, stood one of the great fragmented reclining figures of the 1960s, *Three-Piece Reclining Figure No.1*.

In the formal gardens, there was a mother-and-child, and down by the lake a Goslar Warrior, lying wounded forever in the brooding Yorkshire light.

'I have always enjoyed landscape,' Henry Moore once said, 'and responded to a natural, outdoor environment, rocks and hills, the shape of the earth, the sight of trees and clouds and sky. I like my large sculptures to be outdoors, in landscape.' And certainly, here they looked at home: forms which seem strange, which function by contrast, rather than complementarity, against the rectilinear shapes of the modern city, looked alive, full of light, strangely natural.

85

And then I left the exhibition, and drove around in the surrounding countryside. I recalled what Moore said about the influence of Adel Rocks, and of slag heaps against the sky, that they were like pyramids or the Alps. I began to feel some much deeper attachment between this artist and the land. I began to see how the strangeness of Moore depends upon the acceptance of the forms of the city.

There was much that was not there in that exhibition; there was hardly a carving to be seen. I could not help wondering, what would the young Henry Moore have made of it, if, bearing his chisel, he had stood there. What would he have thought, surrounded not only by bronzes, but by fibreglass models of the arches, locking piece, and other works that began life as eighteen-inch models?

He would, of course, have been angry. Jacquetta Hawkes once described how she stood in Moore's studio and saw one of his reclining figures with the shaft of a belemnite exposed in the thigh, and how this gave her an intense sense of unity: 'I felt that the squid in which life had created that shape, even while it swam in distant seas, was involved in this encounter with the sculptor; that it lay hardening in the mud until the time when consciousness was ready to find it out and imagination to incorporate it in a new form.'[27] There was none of that in the Bretton sculpture park.

And yet the sense of unity was not lost. The painter Derek Hyatt, who also knows this landscape well, writes:

> Beyond Grassington I glimpse the swelling
> forms of the drumlins, the glacial hills that
> move below the high skyline. And what is
> the dark shape in the limestone valley ahead?

86

Kilnsey Crag, always a surprise, crashing out
of the hillside like an enormous Henry
Moore! From the thuds and bumps in the
quarry behind men are still working on it,
inside the hill.[28]

Moore embodied a vision, a vision of man in relation to
nature. His vision, which, like all universals, sprang
from particulars, which rose out of a deep love for the
landscape in which he was born, mingled somehow
with the thought of his mother as protector. That vision
he expressed in the sculptural language of his day: or, to
be more exact, he reinvented that sculptural language
(along with others) in order that it could speak of these
things.

It is a vision comparable to Lincoln cathedral, rising
up on a rock above the city. Moore's vision was at once
spiritual – belonging to the tradition of Ruskin, and the
great cathedrals, and of the Gothic revival, and at the
same time belonging to Yorkshire. The neo-Romantic
roots of Moore's vision lie deep in our national cultural
life.

It is for this reason that Moore is greatly loved and that
he became a national monument. Yet perhaps for the
very same reason – his combination of spirituality and
national, local particularity – he has been criticised by
wave after wave of intellectuals since the last world war.
At his best, though, Moore evaded the deprivation of a
shared symbolic order in our society, and revealed a
fully secular vision of reconciliation of natural and
human form. Through his mastery and imaginative
transformation, he recreates the infant–mother relation-
ship from within, and he also offers a vision of woman
as environment and of environment as woman, and of
all the complexity and difficulty of such a vision.

Moore had the capacity to take the human body, abstract it and split it up into bits in sculpture, without losing it altogether, so that the finished work has a sense of aesthetic unity, deriving from its relationship to the whole body. Thus in his late works where the woman's body is like a series of great rocks drifting apart, he conveys that aspect of the infant–mother relationship which inflects so much of later life: our sense of wholeness and fragmentation, of separation and union, of frustration and well-being, not just in relation to the mother, but in relation to nature itself.

These themes are genuinely universal. We are all born of woman, and we are all part of nature. Moore's vision of woman was not the narrow one of some male sculptors, which sees woman as merely an object of their own immediate sexual desires. And the way in which Moore worked and reworked his theme was highly original.

Ruskin once wrote that an eleven-year-old girl's attempt to fashion creatures out of pastry was 'a true account of the spirit of sculpture'; which he saw as 'zooplastic', that is mimetic, and 'life-shaping'. For Moore, too, the human figure was always at the root of his sculptural transformation. Purely abstract sculpture was, he explained in 1960, an activity better fulfilled in some other art. Purely abstract work had no place in sculpture proper and he always emphasised the necessity for sculptors of drawing from life and from nature. When Moore extended beyond the human body, it was into the rich world of natural forms, such as bones, shells and pebbles. Precisely because of this 'humanist-organicist' dimension of Moore's work, it presents a challenge to a contemporary 'synthetic culture' (as he put it), which has cut itself off from natural roots. There is in Moore a rejection of much of the contemporary

world, of its flatness, its superficiality, its sense of disunity of form. There is an attempt, at a time when so much sculpture is a bag of tricks and gimmicks, to speak of the great themes of human life, and of our relationship to nature.

Without access to a living, iconographic religious tradition, but through his re-invention of sculptural tradition and his rigorous exploration of natural form, Moore was able to show that a secular art of high sentiment is still possible in our time. And at a time when our relationship to the environment which sustains us becomes ever more problematic, it is high time for a critical re-evaluation of the English romantic tradition which deals so tellingly with this relationship, and of Henry Moore as its last great master.

Notes

Chapter 1

1. P. James, *Henry Moore on Sculpture*, London, Macdonald, 1966, p. 73.

Chapter 2

1. N. Pevsner, *Pioneers of Modern Design*, 2nd edn, New York, 1949, p. 135
2. Herbert Read, *A Concise History of Modern Sculpture*, London, Thames & Hudson, 1964, p. 10.
3. ibid. p. 12.
4. H. Gaudier-Brzeska, 'Vortex, Gaudier-Brzeska', *Blast*, No. 1 (1914), p. 155.
5. E. Silber, *The Sculpture of Epstein*, Oxford, Phaidon, 1986.
6. C. Harrison, *English Art and Modernism 1900–1939*, London, Allen Lane, and Bloomington, Indiana University Press, 1981, p. 331.

Chapter 3

1. Reported in Philip James (ed.), *Henry Moore on Sculpture*, London, Macdonald, 1966, p. 146.
2. cf. J. Rothenstein, *Modern English Painters*, Vol. II, *Lewis to Moore*, 2nd edn, London, Macdonald, 1976, p. 314.
3. Quoted in D. Mitchinson (ed.), *Henry Moore's Sculpture, with Comments by the Artist*, London, Macmillan, 1981, p. 50.
4. J. Rothenstein, op. cit., p. 320.
5. ibid, p. 325.
6. Philip James, op. cit., p. 33.

7. R. Fry, *Vision and Design*, Harmondsworth, Penguin Books, 1937, pp. 88–9.

8. James, op. cit., p. 172.

9. ibid, p. 73.

10. cf. T. Friedman, 'Epsteinism', *Jacob Epstein Sculpture and Drawings*, Leeds City Art Galleries, London, Whitechapel Art Gallery, 1987.

11. Herbert Read, *Henry Moore, Sculptor*, London, Zwemmer, 1934, p. 7.

12. Reproduced in C. Neave, *Leon Underwood*, London, Thames & Hudson, 1974, plate 63.

13. Quoted in *Sculpture: 1850 and 1950*, London, London County Council, 1957, n.p.

14. John Ruskin, *Modern Painters*, Vol. I in *The Works of John Ruskin*, ed. E. T. Cook and A. Wedderburn, Vol. III, p. 427.

15. L. Underwood, *Art for Heaven's Sake*, London, Faber & Faber, 1934.

16. Read, op. cit., p. 12.

17. Harrison, op. cit., p. 331.

18. James, op. cit., p. 68.

19. Mitchinson, op. cit., p. 46.

20. Quoted in *Sutherland: the Early Years*, exhibition catalogue, London, 1986, p. 31.

21. R. Ironside, *Painting Since 1939*, London, Longmans Green (for the British Council), 1947, p. 25.

22. ibid, p. 10.

23. John Read, *Henry Moore: Portrait of an Artist*, London, Whizzard (Deutsch), 1979, p. 82.

24. E. Neumann, *The Archetypal World of Henry Moore*, London, Routledge & Kegan Paul, 1959, pp. 63–4.

25. Both reproduced in *Modern Painters, A Quarterly Journal of the Fine Arts*, Vol. 1, No. 1 (Spring 1988), p. 93.

26. Eric Newton, 'Henry Moore's Madonna and Child', *Architectural Review*, May 1944, p. 140.
27. G. Gowrie, quoted in P. Fuller, 'Hacking Holes in Henry Moore', *Sunday Telegraph*, 18 September 1988.
28. Herbert Read, *Henry Moore, Sculpture and Drawings*, London, Lund Humphries, 1944, p. xxxvi.
29. A. Bowness (ed.), *Henry Moore: Complete Sculpture*, Vol. IV, London, Lund Humphries, 1977, p. 8.
30. K. Clark, *Henry Moore, Drawings*, London, Thames & Hudson, 1974, p. 200.
31. Bowness, op. cit.
32. James, op. cit., p. 266.
33. Mitchinson, op. cit., p. 246.
34. James, op. cit., p. 90.
35. Herbert Read, *A Concise History of Modern Sculpture*, London, Thames and Hudson, 1964, pp. 14–15.

Chapter 4
1. cf. P. Fuller, 'The Value of Art', *New Society*, 29 January, 1988.
2. On Barnett's film and the responses to it, cf. P. Fuller, 'Hacking Holes in Henry Moore', *Sunday Telegraph*, 18 September 1988, and his 'Open Letter to Anthony Barnett', *Modern Painters*, Vol. 1, No. 3 (1988), pp. 4–5.
3. C. Greenberg, *The Collected Essays and Criticism*, Vol. 2, *Arrogant Purpose, 1945–1949*, Chicago, University of Chicago Press, 1986, pp. 126–7.
4. ibid.
5. ibid, p. 318.
6. Quoted in Henry Seldis, *Henry Moore in America*, New York, LACMA, Praeger; Oxford, Phaidon, 1973, p. 136.
7. ibid, p. 135.

8. Quoted in Roger Berthoud, *The Life of Henry Moore*, London, Faber & Faber, 1987, p. 289. Caro spoke further and arguably more measuredly about Moore in *Modern Painters*, Vol. 1, No. 3 (1988), pp. 6–13.
9. M. Fried, 'Introduction', *Anthony Caro*, London, Arts Council, Hayward Gallery, 1969, p. 16.
10. Herbert Read, *A Concise History of Modern Sculpture*, London, Thames & Hudson, 1964, pp. 250–3.
11. Caro, too, disagrees. cf. A. O'Hear, 'Caro on Teaching', *Modern Painters*, Vol. 4. No. 2 (1991), pp. 77–9, at p. 78.
12. Roger Scruton, 'Aesthetic Atheist', *The Listener*, 20 June 1985, p. 26.
13. Williams himself was appointed Professor of Sculpture at the Royal College of Art in 1990.

Chapter 5
1. D. W. Winnicott, *The Maturational Processes and the Facilitating Environment*, London, 1972, p. 39.
2. D. W. Winnicott, *Playing and Reality*, Harmondsworth, Penguin Books, 1974, p. 152.
3. ibid, p. 45.
4. For Winnicott's attitude to Melanie Klein, see his paper, 'A personal view of the Kleinian Contribution', in *The Maturational Processes and the Facilitating Environment*, London, 1972, pp. 171–8.
5. cf. David Mitchinson, p. 50, and op. cit., Philip James, op. cit., p. 220.
6. For an introduction to Winnicott's basic ideas – on which these remarks are based – see Peter Fuller, 'Donald Winnicott', in *The Naked Artist*, London, 1983.
7. See Winnicott's seminal paper, 'Transitional Objects and Transitional Phenomena', in *Playing and Reality*, pp. 1–30.
8. For a full discussion of this 'third area' see the papers

gathered in the latter part of *Playing and Reality*,
especially 'The Location of Cultural Experience',
pp. 112–21.

9. D. W. Winnicott, *Playing and Reality*, p. 128.

10. ibid, p. 118.

11. Charles Rycroft, *Psychoanalysis and Beyond*, ed. Peter
Fuller, London, 1985.

12. Madeleine Davis and David Wallbridge, *Boundary and
Space*, London, 1981, p. 143.

13. ibid, p. 146.

14. James, op. cit., p. 50.

15. Henry Moore, *Henry Moore at the British Museum*,
London, 1981, p. 125.

16. For Moore's statements on his changing attitudes to
stone carrying, see Philip James, op. cit., p. 135.

17. ibid, p. 113.

18. Quoted in Mitchinson, op. cit., p. 65.

19. A. D. B. Sylvester, 'The Evolution of Henry Moore's
Sculpture', p. 164.

20. Mitchinson, op. cit., p. 228.

21. ibid, p. 81.

22. ibid, p. 88.

23. Will Grohmann, *The Art of Henry Moore*, London,
Thames & Hudson, 1960, p. 137.

24. P. Fuller, *Theoria*, London, Chatto & Windus, 1988.

25. Davis and Wallbridge, op. cit., p. 57.

26. Davis and Wallbridge, op. cit., p. 150.

27. Jacquetta Hawkes, *A Land*, Harmondsworth, Penguin
Books, 1959, p. 94.

28. Derek Hyatt, obituary notice for Henry Moore, *The
Dalesman*, April 1987, p. 53.

Index

Index

Mother and Child (1922), 22–3
Mother and Child (Norwich, 1932), 29
Mother and Child (1936, Ancaster stone), 32–3
Mother and Child (1936, upright), 33
Mother and Child (1939, Ancaster stone), 69
Mother and Child holding Apple II (drawing, 1981), 26
Much Hadham, 37; Henry Moore Foundation at, 4

Nash, Paul, 30
Negro sculpture, 20, 25
neo-Classicism, 10, 42–3
neo-Romanticism, 35–6, 38, 41, 57, 87
Neumann, Erich, 38–9, 76
'New Sculpture' movement (1880s), 11–12, 13
'New Sculpture' (1980s), 63–4, 65, 83
Newton, Eric, 40
Nicholson, Ben, 30
Nuclear Energy (1964), 47

Ontario Art Gallery, Moore's drawing of a woman's buttocks in (1923), 52

Paddington Green Children's Hospital, Winnicott's association with, 71, 72
Palmer, Samuel, 34
Pater, Walter, 44
Perry, Green, near Much Hadham, Moore's home at, 37, 81
Pevsner, Antoine, 12, 13
Picasso, Pablo, 31, 34
Piper, John, 35
'pointing up' machine/techniques, 8, 10, 13, 21, 49, 58
Pope, Nicholas, 63
'potential space', Winnicott's notion of, xii, 74–5
Pre-Raphaelites, 15, 24, 42
'primitive' art, xiii, 20–1, 22, 30, 42
Profumo affair, 62

Radetsky, Irina see Moore
Read, Herbert, 3, 26, 28, 35, 41, 57, 58, 60–1; A Concise History of Modern Sculpture, 13, 49–50

Read, John, 38
'Reality Principle', 83
'reclining figure' theme, xiii, 23, 26, 29, 30, 33, 36, 42, 43, 44, 45, 46–7, 48, 49, 54, 55, 71, 81–2
Reclining Figure (Leeds, 1929), 25
Reclining Figure (1937), 33
Reclining Figure (1945–6), 43, 78
Reclining Figure (UNESCO, 1957–8), 42, 44
Reclining Figure (1959), 45, 46
Reclining Woman (Ottawa, 1930), 25, 29
Recumbent Figure (Tate, 1938), 33–4, 35
Richards, J. M., 3
Rodin, Auguste, 13, 14, 60
Romanesque, English, 39
Romanticism, English/British, ix, xiii, 6, 17, 28, 30, 35, 36, 56, 89
Rossetti, Dante Gabriel, 16
Rothenstein, Sir John, 23, 24, 28, 35
Rothenstein, Sir William, 19, 52
Royal College of Art, Moore's studies at, 20, 25, 27, 52, 53; and resignation from (1931), 29
Ruskin, John, xi, 7, 15, 19, 28, 36, 48, 54, 56, 87, 88
Russell, John, 4
Rycroft, Charles, 75

St Matthew's Church, Northampton, Madonna commissioned for, 39, 40
Scruton, Roger, 65
Second Nature (book), 55
Second World War, 3, 37–41, 42
Sheep grazing in long grass No. 1 (1981), 55
'Sheep Sketchbook', 54
shelter drawings, Moore's 37, 38–9, 79, 80
Shelter Scene: Two Swathed Figures, 39
Silber, Evelyn, 15
stained glass, 55
Stevens, Alfred, 11, 12
stone-cutting, 14, 21, 22
stringed figures, Moore's, 31, 33, 48, 78–9
Stubbs, George, 54
Suckling Child (alabaster), 25
Surrealism, European, 31

97